How to Draw
MYTHICAL
MONSTERS
AND MAGICAL CREATURES

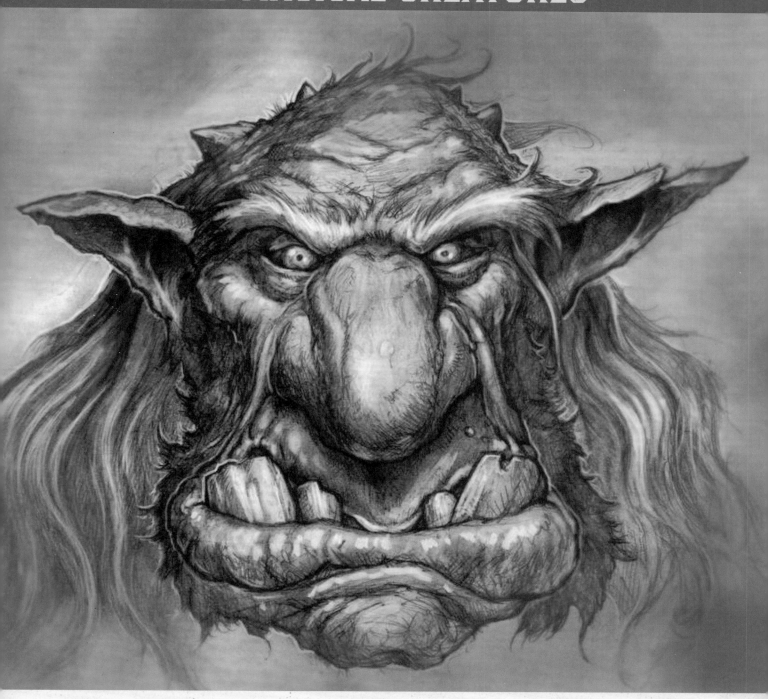

Thunder Bay Press
An imprint of Printers Row Publishing Group
10350 Barnes Canyon Road, Suite 100, San Diego, CA 92121
www.thunderbaybooks.com

Thunder Bay Press

Publisher: Peter Norton
Associate Publisher: Ana Parker
Publishing/Editorial Team: April Farr, Kelly Larsen, Kathryn C. Dalby
Editorial Team: JoAnn Padgett, Melinda Allman, Dan Mansfield

ISBN: 978-1-64517-138-6

Printed in China

23 22 21 20 19 1 2 3 4 5

How to Draw
MYTHICAL
MONSTERS
AND MAGICAL CREATURES

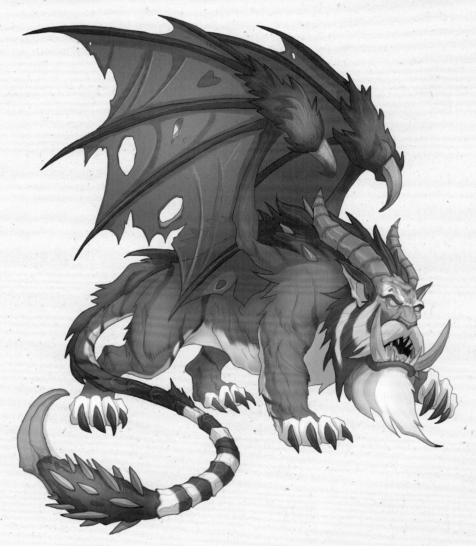

WRITTEN AND ILLUSTRATED BY SAMWISE DIDIER

Thunder Bay
P·R·E·S·S

San Diego, California

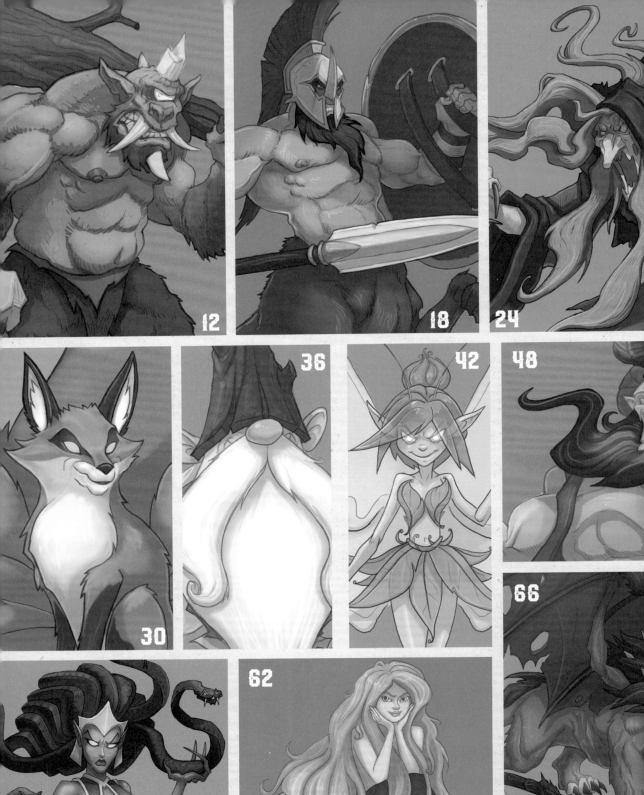
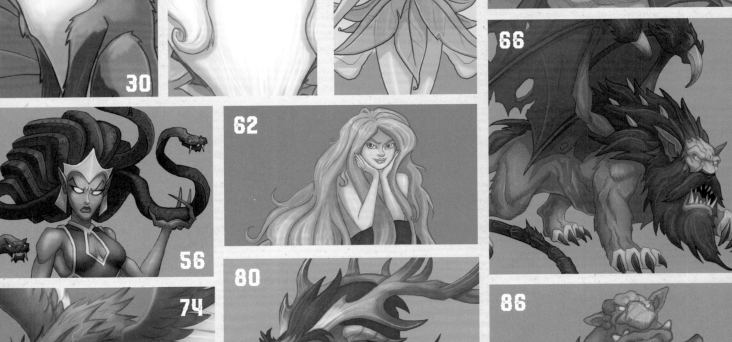

12

18

24

36

42

48

30

66

62

56

80

74

86

TABLE OF CONTENTS

ABOUT THE AUTHOR

SAMWISE DIDIER is an artist, illustrator, and writer who cannot seem to stop drawing monsters, or writing stories about them. Some notable works from Samwise include *Grimbeard: Tales of the Last Dwarf*, *Strange Highways*, *The Last Winter*, and this lovely book you hold in your hands today.

Aside from drawing and creating artwork on his own projects, Samwise is also a senior art director at Blizzard Entertainment, which he joined back in 1991. Over the last two decades, Samwise has been responsible for directing the art style for the Warcraft, StarCraft, and Heroes of the Storm franchises, as well as for creating artwork for the World of Warcraft, Hearthstone, and Diablo games.

Photo by Raphaelle Monvoisin

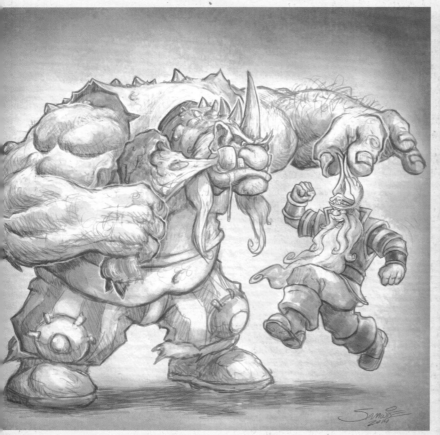

ART FROM GRIMBEARD, TALES OF THE LAST DWARF

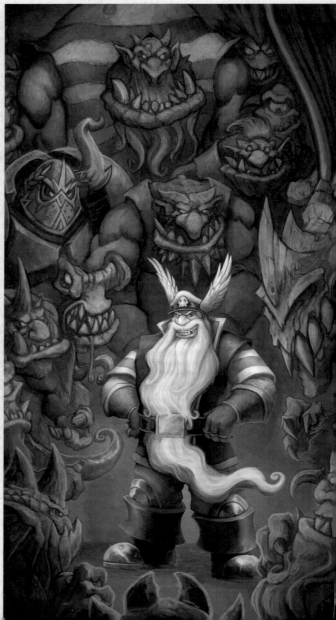

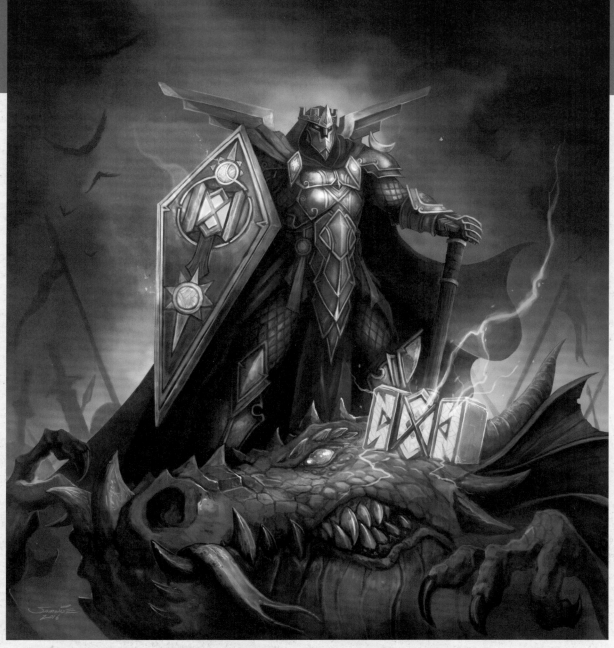

ART CREATED FOR
HAMMERFALL,
HAMMER HIGH

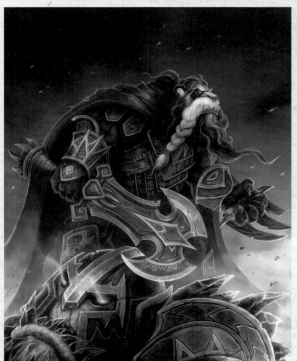

Far left:
ART FROM THE
LAST WINTER

Left:
ART FROM STRANGE
HIGHWAYS

GETTING STARTED

These pages will guide you through the process I use to create the mythical monsters and magical creatures captured in this book. The first thing I do is generate some rough sketches for what the creature will look like, and some quick poses that I think they might look good in. This takes a little more time, but once I figure out all the details, it makes the step-by-step process go much smoother.

One thing that I would like you to know is that if your first attempts don't come out looking exactly like the images in the book, that's OK. It takes time to learn new styles and new techniques. Just keep practicing and they will get better with each one you create. I have been creating art since I was three years old, and sometimes the things I draw still look like those first attempts. We all need to keep practicing. Who knows, maybe one day I will be picking up your book on how to draw!

A.B.C., ALWAYS BE CREATING!

Samwise

IT TOOK MANY ROUGH SKETCHES TO DEVELOP THE CHARACTERS IN THIS BOOK BEFORE I GOT TO THIS.

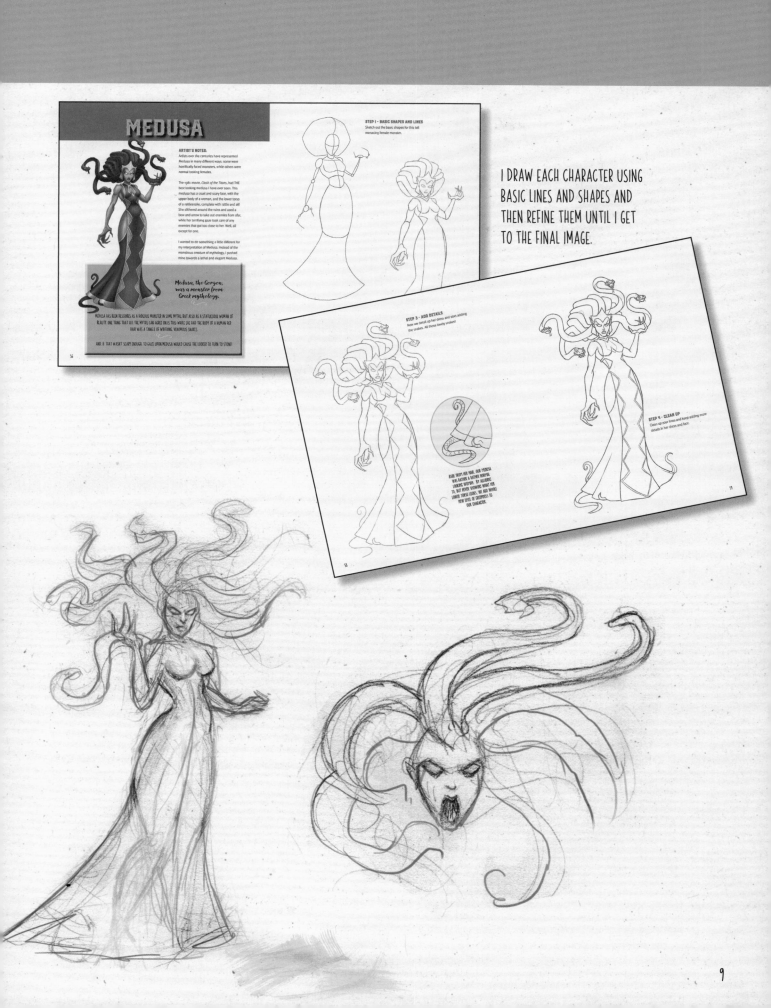

MEDUSA

I DRAW EACH CHARACTER USING BASIC LINES AND SHAPES AND THEN REFINE THEM UNTIL I GET TO THE FINAL IMAGE.

TOOLS & MATERIALS

The main thing you need for this book is a regular pencil with an eraser, and some paper. If you already have more profession materials, those will work fine as well. I just want to you to know that you don't need to spend a ton of money to create art and have fun. With just a pencil, paper, and practice, you can create all the mythical monsters in this book!

ARTIST NOTE:

To show you what you can do with normal, everyday items and *lots* of practice, I am including some artwork I have done with just a regular pencil and some copy paper.

I USED A PLAIN PENCIL AND A SIMPLE SHEET OF COPY PAPER TO CREATE THESE IMAGES.

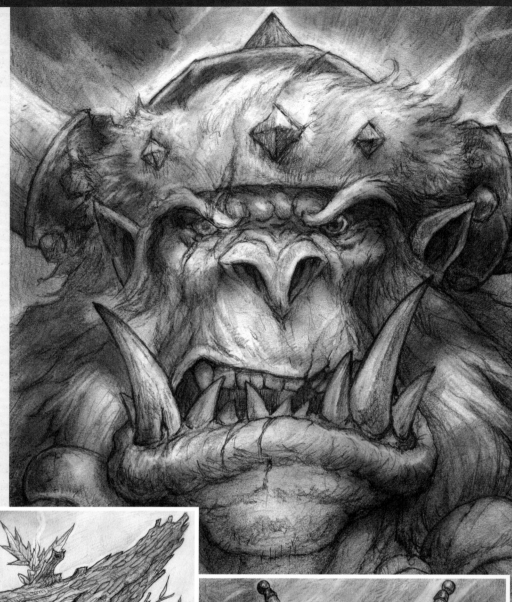

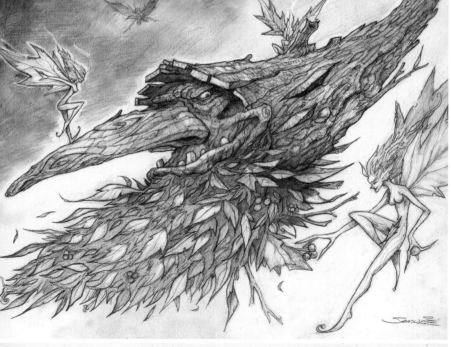

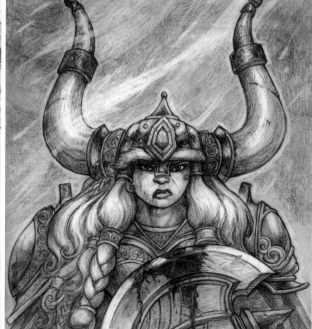

10

Once you have created a few monsters, you can start experimenting with more advanced techniques, like shading and even coloring your monsters. You can shade with the same pencil you used to draw the monsters, and you can color them in so many ways; try using watercolors, or colored pencils and markers, and even higher-end digital coloring on the computer. It all depends what you have on hand, and what you are comfortable working with. I would suggest you photocopy your original art, or scan your art and print it out first before you try shading or coloring on your original.

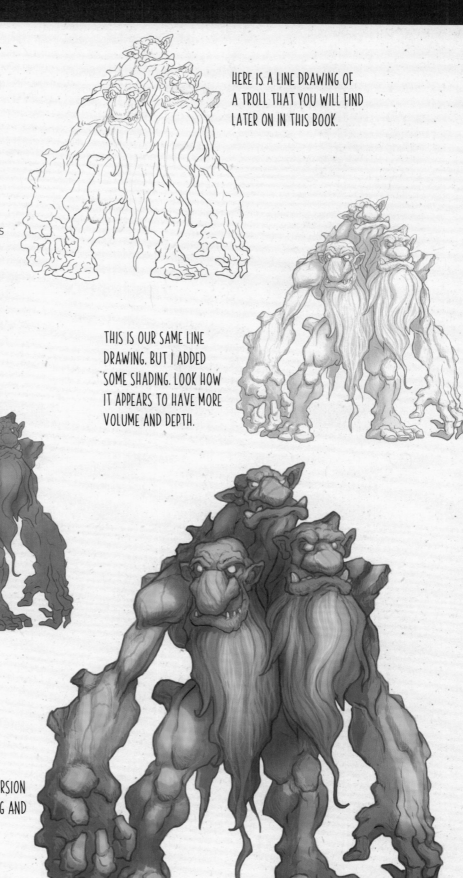

HERE IS A LINE DRAWING OF A TROLL THAT YOU WILL FIND LATER ON IN THIS BOOK.

THIS IS OUR SAME LINE DRAWING, BUT I ADDED SOME SHADING. LOOK HOW IT APPEARS TO HAVE MORE VOLUME AND DEPTH.

HERE IS OUR LINE DRAWING WITH A SIMPLE COLOR PASS ON IT.

AND HERE IS ANOTHER VERSION THAT HAS BOTH COLORING AND SHADING COMBINED!

CYCLOPS

ARTIST'S NOTE:

The Cyclops is probably my favorite mythical creature, and this guy was the first monster I created for this book. It was originally done as just a test, but I was so happy with the final art, I decided to keep it in the book.

My first encounter with the Cyclops was not from reading books on Greek mythology, but from watching a movie called *The Seventh Voyage of Sinbad* with my dad when I was a kid. The Cyclops created for this book is inspired by the Cyclops from the movie, and is dedicated to the great Ray Harryhausen. Thank you for creating so many beautiful monsters over your career.

The word Cyclops means "round eye."

THE CYCLOPS ARE FOUND THROUGHOUT GREEK AND ROMAN MYTHOLOGY AND ARE SAID TO BE THE GIANT OFFSPRING OF THE GODS AND BROTHERS TO THE TITANS. THEY HAVE BEEN DESCRIBED IN MANY WAYS THROUGHOUT HISTORY: SOMETIMES AS SAVAGE AND BRUTAL, BUT ALSO AS GREAT BUILDERS AND BLACKSMITHS. THERE ARE EVEN TALES OF CYCLOPS BEING SHEPHERDS TO LARGE HERDS.

THERE IS ONE UNIFYING FEATURE THAT RUNS THROUGHOUT ALL THE STORIES, AND IT IS THAT CYCLOPS HAVE ONLY ONE EYE.

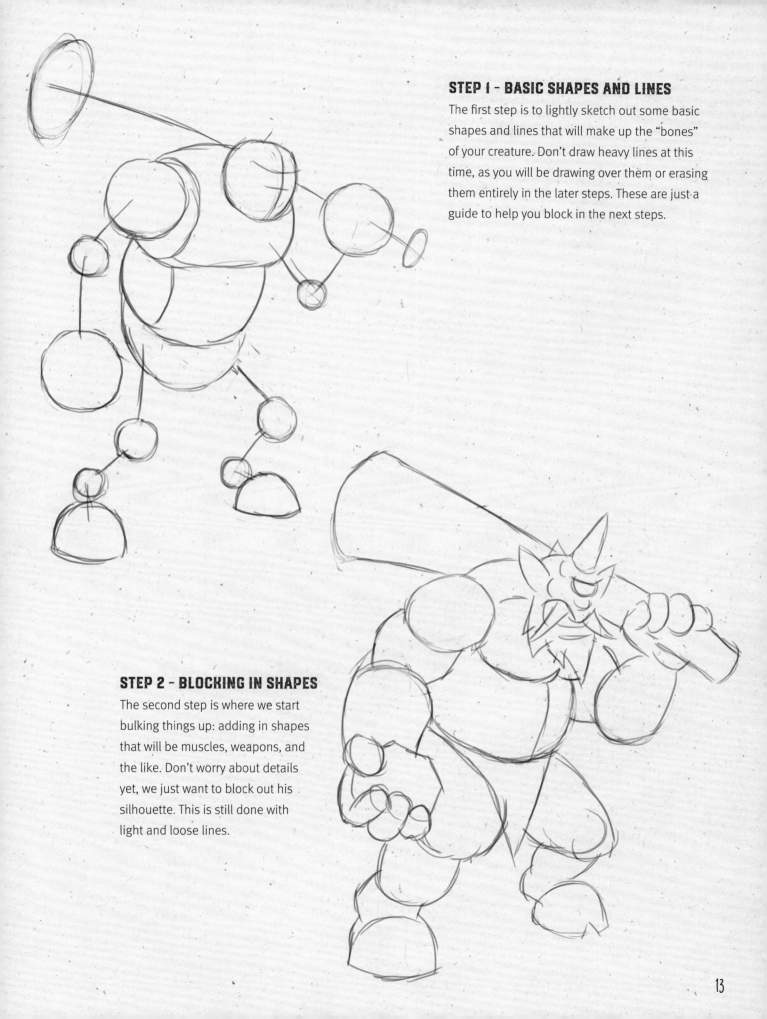

STEP 1 - BASIC SHAPES AND LINES

The first step is to lightly sketch out some basic shapes and lines that will make up the "bones" of your creature. Don't draw heavy lines at this time, as you will be drawing over them or erasing them entirely in the later steps. These are just a guide to help you block in the next steps.

STEP 2 - BLOCKING IN SHAPES

The second step is where we start bulking things up: adding in shapes that will be muscles, weapons, and the like. Don't worry about details yet, we just want to block out his silhouette. This is still done with light and loose lines.

13

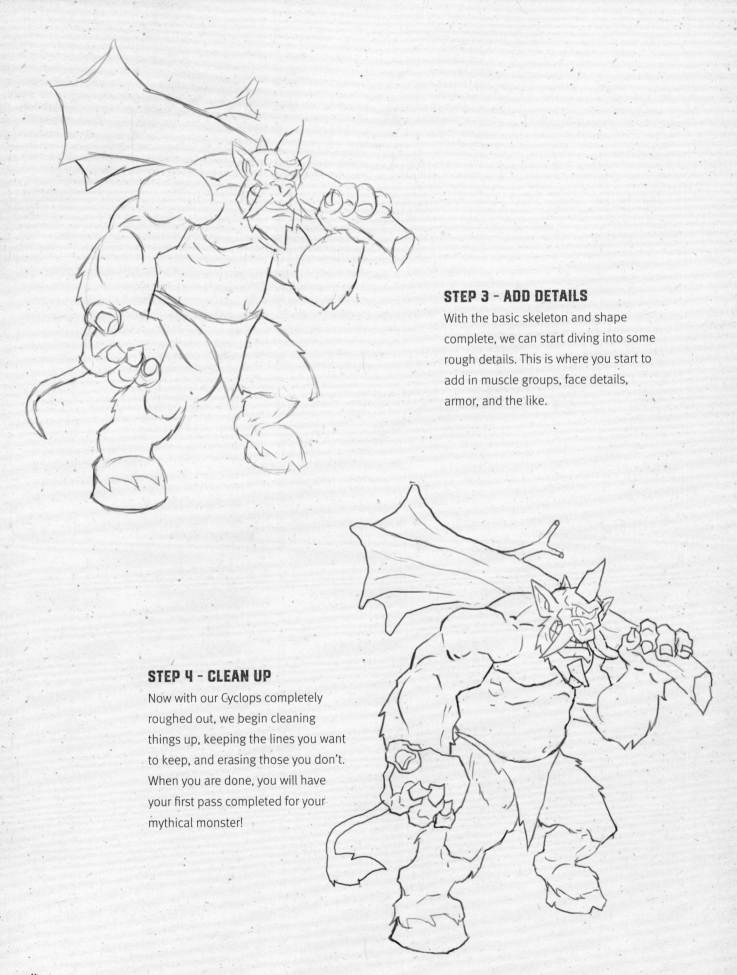

STEP 3 - ADD DETAILS

With the basic skeleton and shape complete, we can start diving into some rough details. This is where you start to add in muscle groups, face details, armor, and the like.

STEP 4 - CLEAN UP

Now with our Cyclops completely roughed out, we begin cleaning things up, keeping the lines you want to keep, and erasing those you don't. When you are done, you will have your first pass completed for your mythical monster!

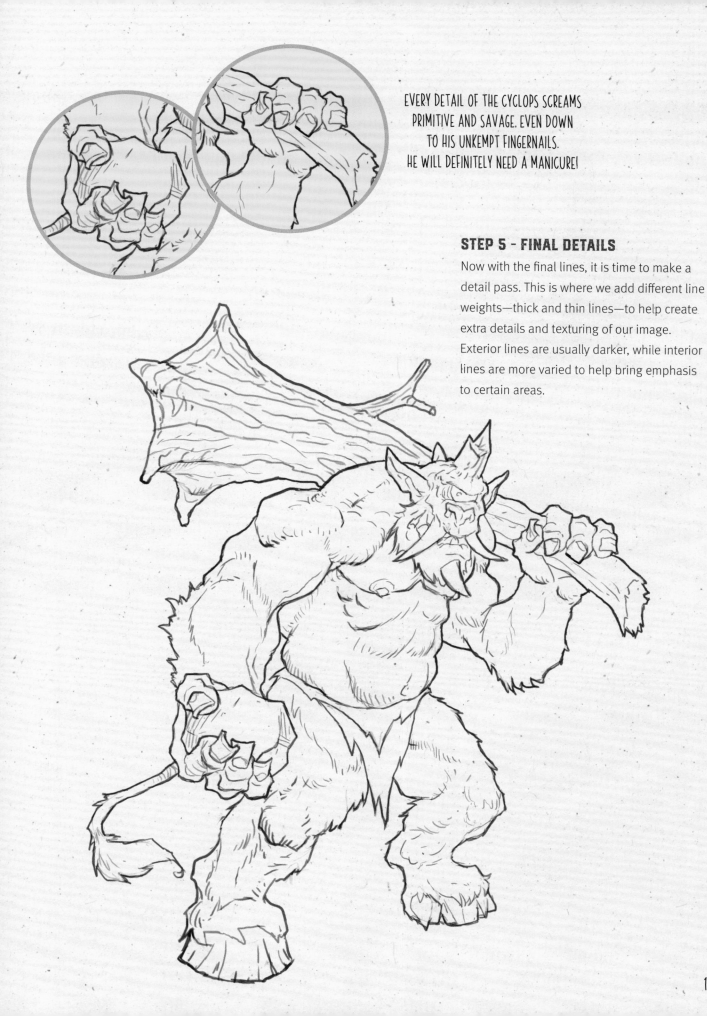

EVERY DETAIL OF THE CYCLOPS SCREAMS
PRIMITIVE AND SAVAGE. EVEN DOWN
TO HIS UNKEMPT FINGERNAILS.
HE WILL DEFINITELY NEED A MANICURE!

STEP 5 - FINAL DETAILS

Now with the final lines, it is time to make a detail pass. This is where we add different line weights—thick and thin lines—to help create extra details and texturing of our image. Exterior lines are usually darker, while interior lines are more varied to help bring emphasis to certain areas.

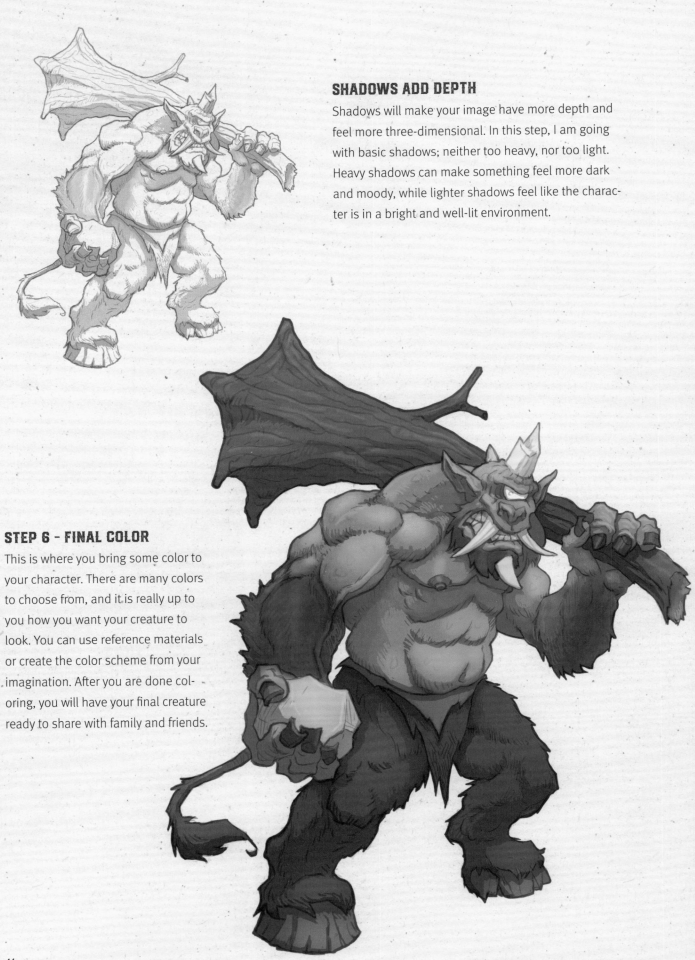

SHADOWS ADD DEPTH

Shadows will make your image have more depth and feel more three-dimensional. In this step, I am going with basic shadows; neither too heavy, nor too light. Heavy shadows can make something feel more dark and moody, while lighter shadows feel like the character is in a bright and well-lit environment.

STEP 6 - FINAL COLOR

This is where you bring some color to your character. There are many colors to choose from, and it is really up to you how you want your creature to look. You can use reference materials or create the color scheme from your imagination. After you are done coloring, you will have your final creature ready to share with family and friends.

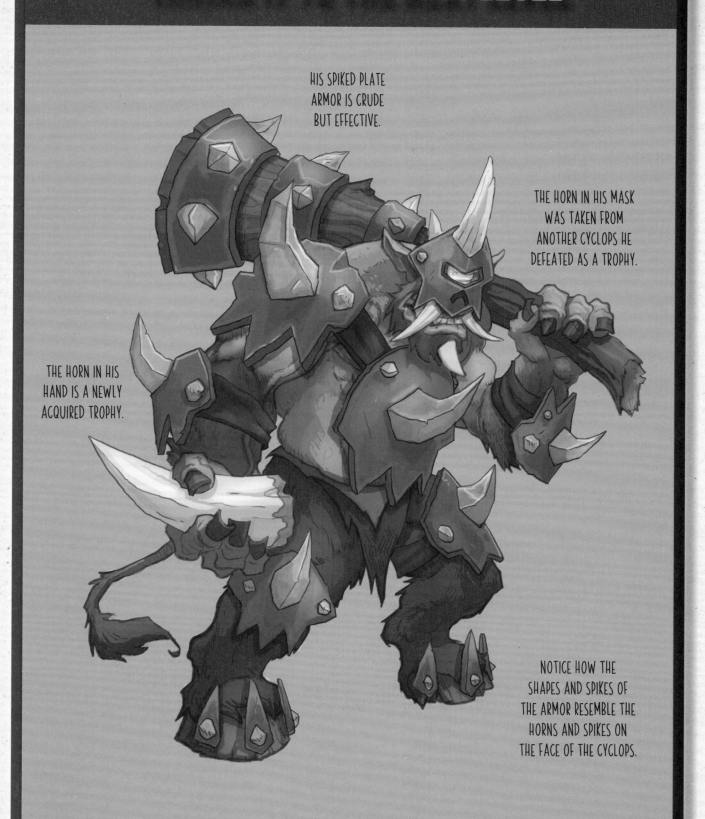

HIS SPIKED PLATE ARMOR IS CRUDE BUT EFFECTIVE.

THE HORN IN HIS MASK WAS TAKEN FROM ANOTHER CYCLOPS HE DEFEATED AS A TROPHY.

THE HORN IN HIS HAND IS A NEWLY ACQUIRED TROPHY.

NOTICE HOW THE SHAPES AND SPIKES OF THE ARMOR RESEMBLE THE HORNS AND SPIKES ON THE FACE OF THE CYCLOPS.

CENTAUR

ARTIST'S NOTES:

Similar to humans and horses, Centaurs have been described as violent and unruly, but in other stories they are more disciplined and learned. For our Centaur, I'm going with a combination of the two. By showing our Centaur wielding spear and shield, as well as a Trojan-inspired helmet, it shows that this once-wild Centaur has been taught the martial discipline of a soldier.

Both the constellation and the zodiac symbol for Sagittarius are depicted as a centaur.

CENTAURS ARE FOUND THROUGHOUT GREEK AND ROMAN MYTHOLOGY AND ARE VERY ICONIC IN APPEARANCE. THERE ARE SOME SMALL VARIETIES IN MYTHOLOGY, BUT THIS DOMINANT REPRESENTATION OF THE CENTAUR IS A BEING HAVING THE UPPER TORSO OF A HUMAN AND THE LOWER TORSO OF A HORSE.

THE GREEK HERO ACHILLES WAS TAUGHT HOW TO USE THE BOW AND TO PLAY THE LYRE BY THE CENTAUR CHIRON.

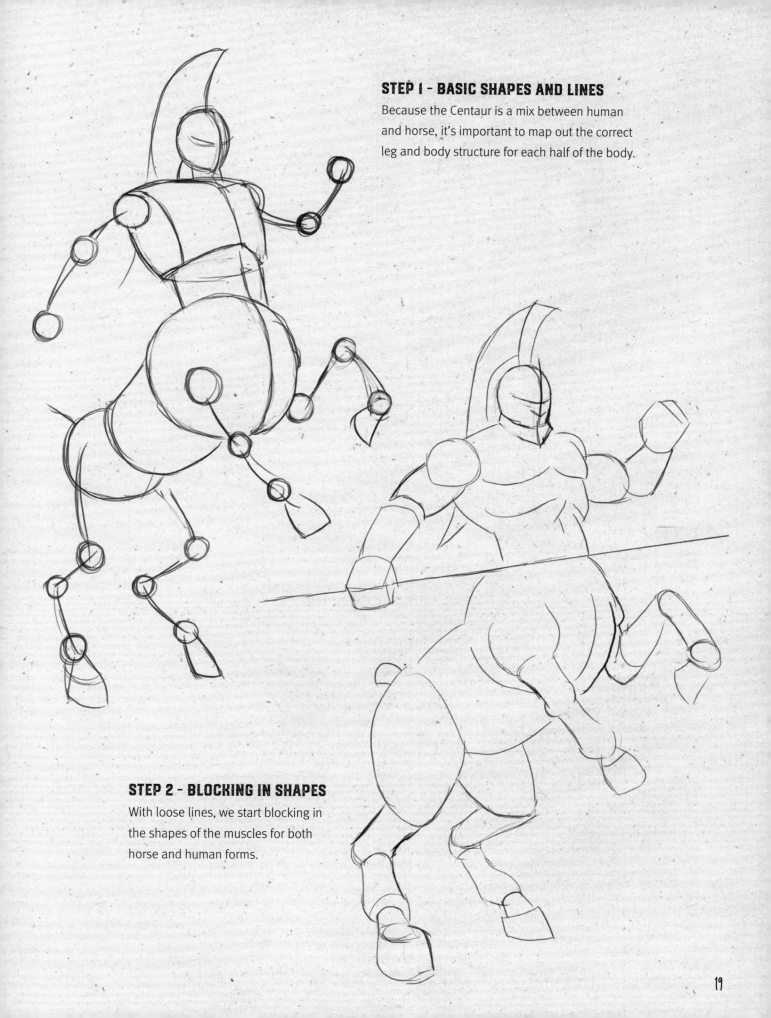

STEP 1 - BASIC SHAPES AND LINES

Because the Centaur is a mix between human and horse, it's important to map out the correct leg and body structure for each half of the body.

STEP 2 - BLOCKING IN SHAPES

With loose lines, we start blocking in the shapes of the muscles for both horse and human forms.

STEP 3 - ADD DETAILS

Now it's time to rough in the weapon shapes of his spear and shield. Add more details in the face and helmet, and don't forget to add his tail.

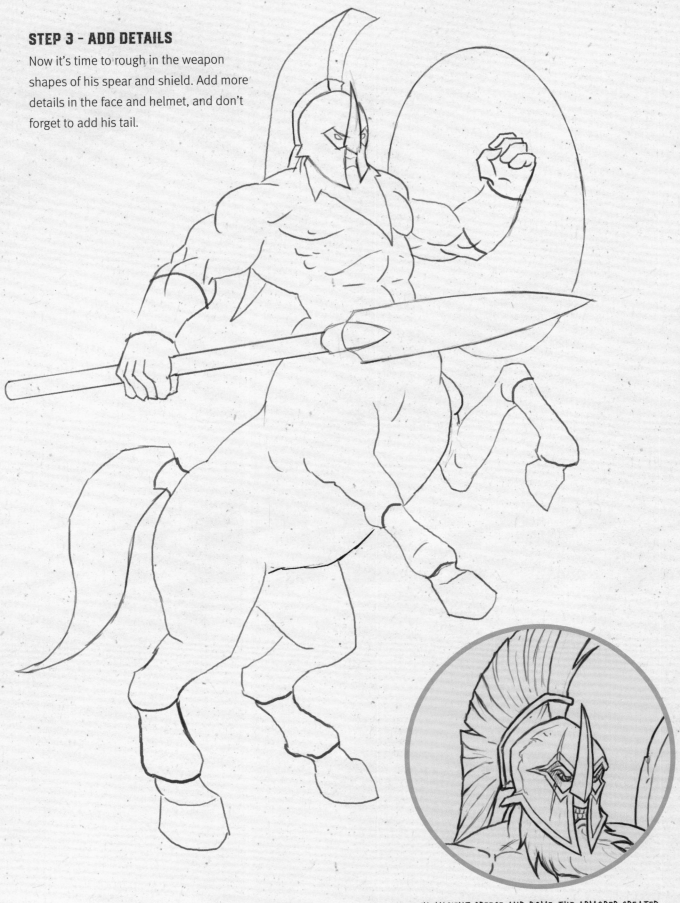

IN ANCIENT GREECE AND ROME. THE ARMORER CREATED THE PLUMES ON THE HELMETS OUT OF HORSE HAIR. IF SO. MAYBE THAT IS WHY OUR CENTAUR LOOKS SO ANGRY.

STEP 4 - CLEAN UP

Now with the Centaur roughed out, we begin cleaning things up, keeping the lines you want to keep and erasing those you don't. Add more detail to his helmet, armor, and leg wraps, as well as more detail to his beard and tail.

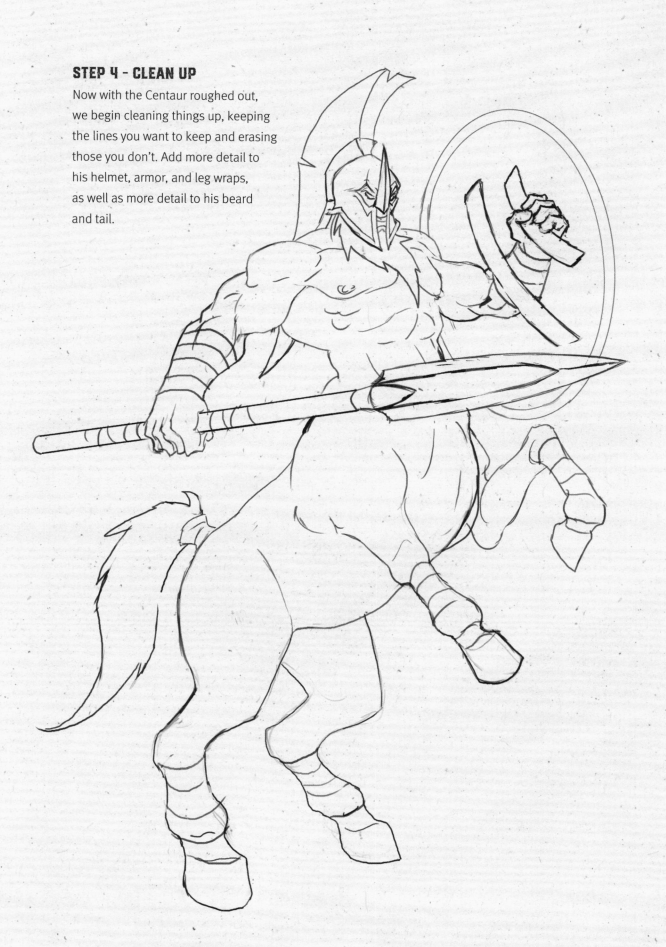

STEP 5 - FINAL DETAILS

Now it is time for our final detail pass. Add wood grain to his spear shaft and add the final details to his muscles, hooves, and fur.

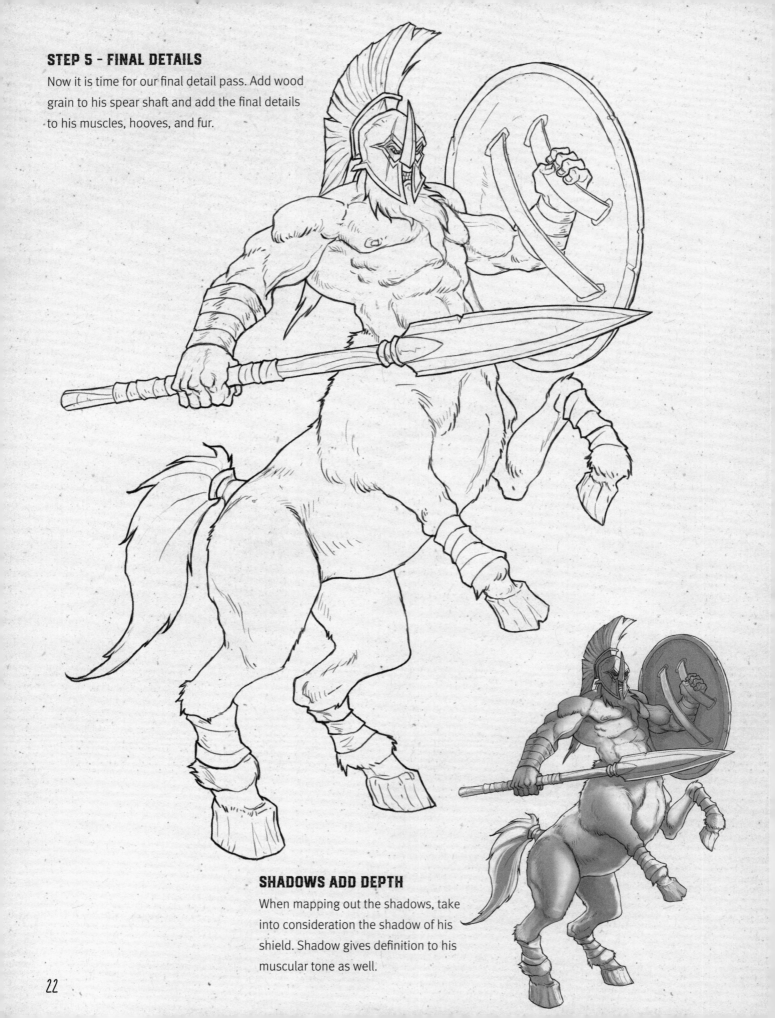

SHADOWS ADD DEPTH

When mapping out the shadows, take into consideration the shadow of his shield. Shadow gives definition to his muscular tone as well.

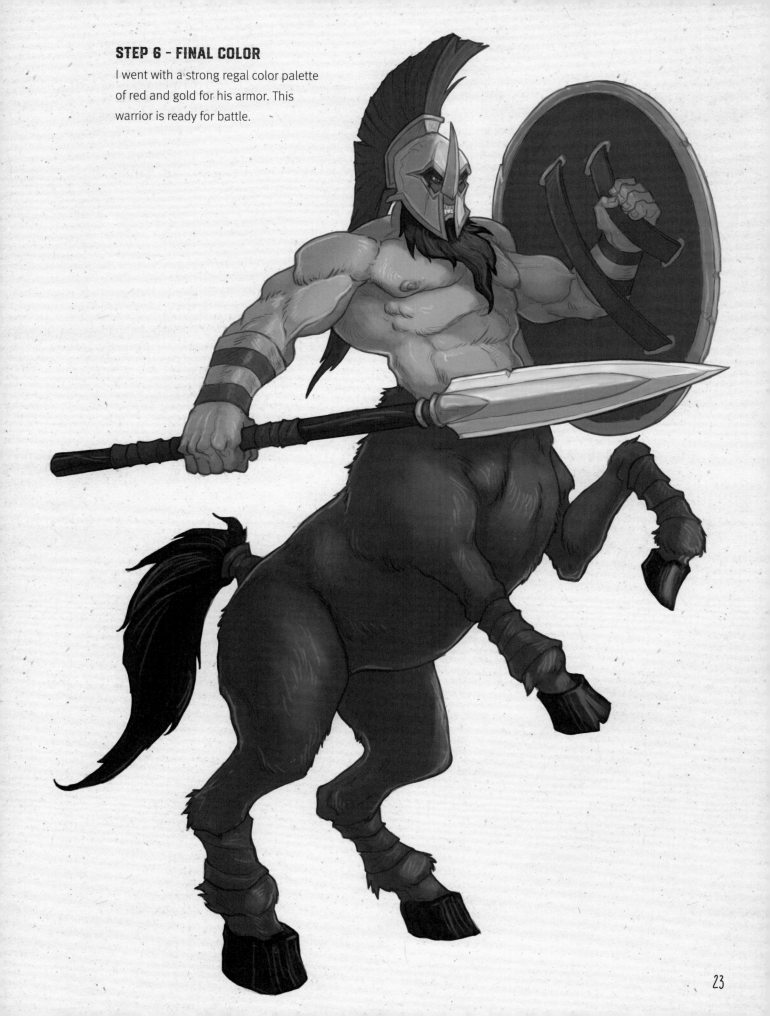

STEP 6 - FINAL COLOR

I went with a strong regal color palette of red and gold for his armor. This warrior is ready for battle.

BANSHEE

ARTIST'S NOTES:

Numerous tales have depicted the Banshee crying under old, withered trees or hovering over earthen graves. But some stories have the Banshee wailing in grief as she flies across the moon! That is a whole different kind of terrifying!

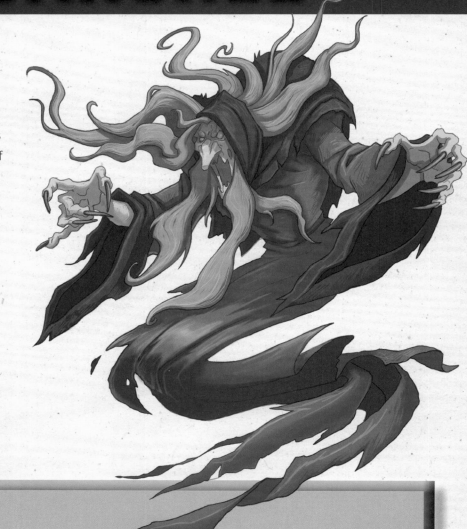

The Banshee is a female spirit or "fairy woman" in Irish mythology.

THE WAILING BANSHEE USUALLY APPEARS AS A TALL, OLD WOMAN DRESSED IN GRAY CLOAKS OR AS A SHORT, STOOPED HAG WITH RATTY CLOTHING AND WISPY HAIR.

THE SIGHT OF A BANSHEE IS A GRIM OMEN INDEED, FOR HER APPEARANCE HERALDS THE IMMINENT DEATH OF A FAMILY MEMBER OR LOVED ONE.

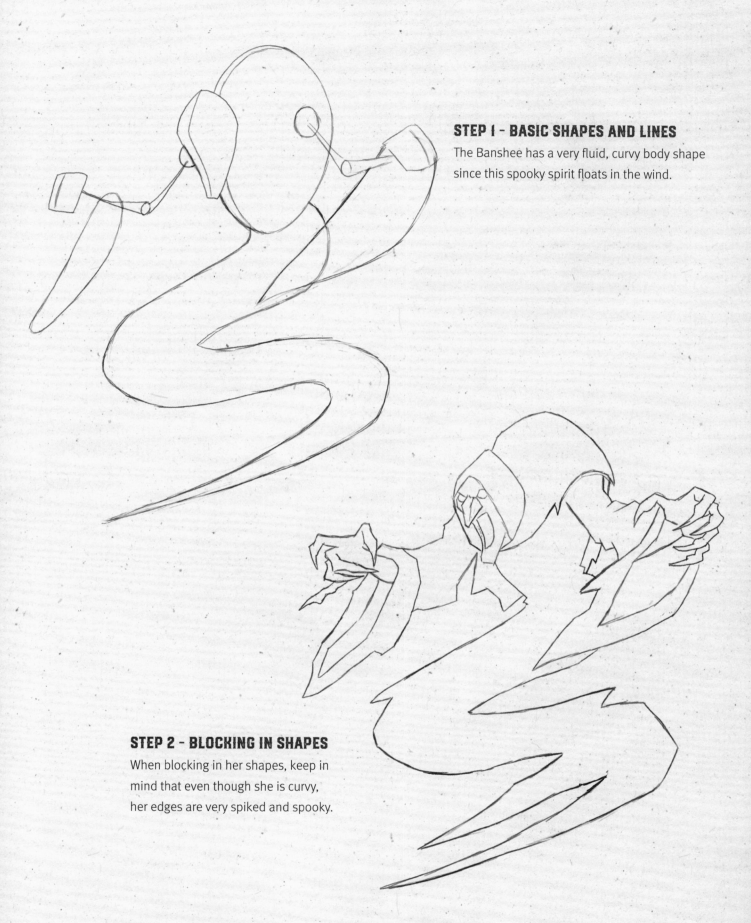

STEP 1 - BASIC SHAPES AND LINES

The Banshee has a very fluid, curvy body shape since this spooky spirit floats in the wind.

STEP 2 - BLOCKING IN SHAPES

When blocking in her shapes, keep in mind that even though she is curvy, her edges are very spiked and spooky.

STEP 3 - ADD DETAILS

With the basic skeleton and shape complete,
we can start diving into the details of her
jagged, flowing clothes and wispy body shape.

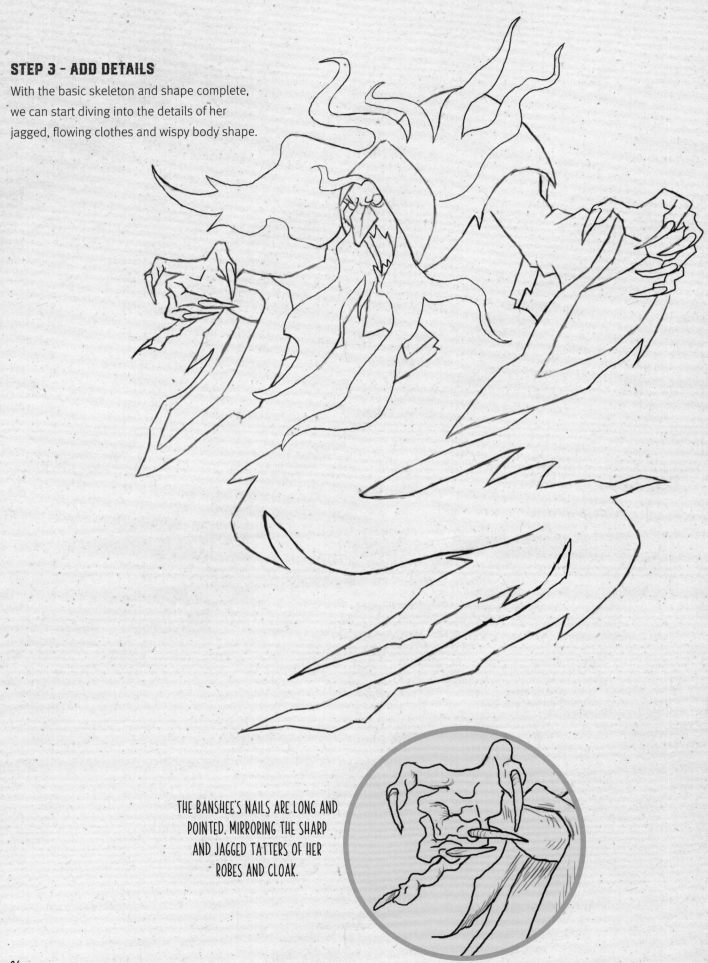

THE BANSHEE'S NAILS ARE LONG AND
POINTED, MIRRORING THE SHARP
AND JAGGED TATTERS OF HER
ROBES AND CLOAK.

STEP 4 - CLEAN UP

Now with our Banshee completely roughed out, we begin cleaning things up, keeping the lines you want to keep.

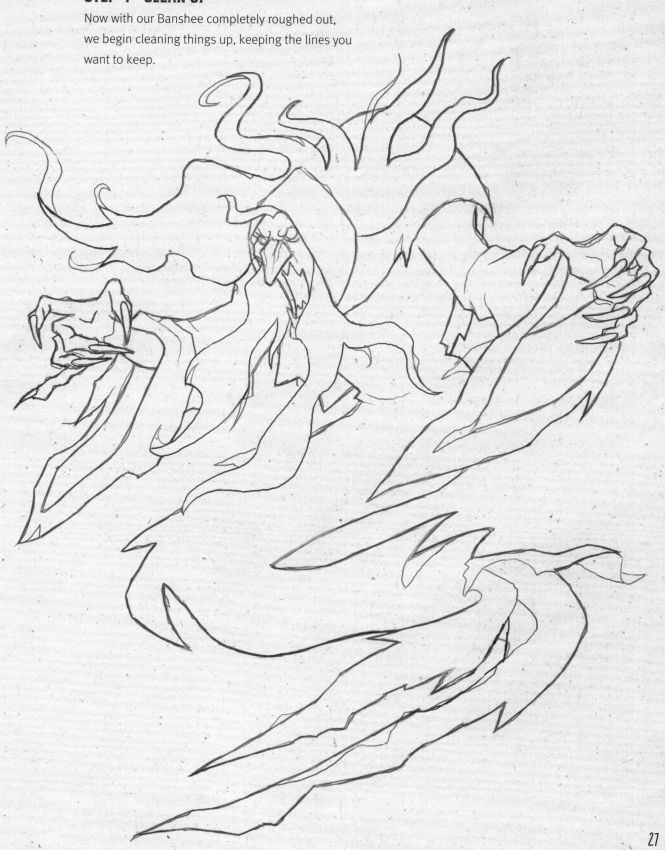

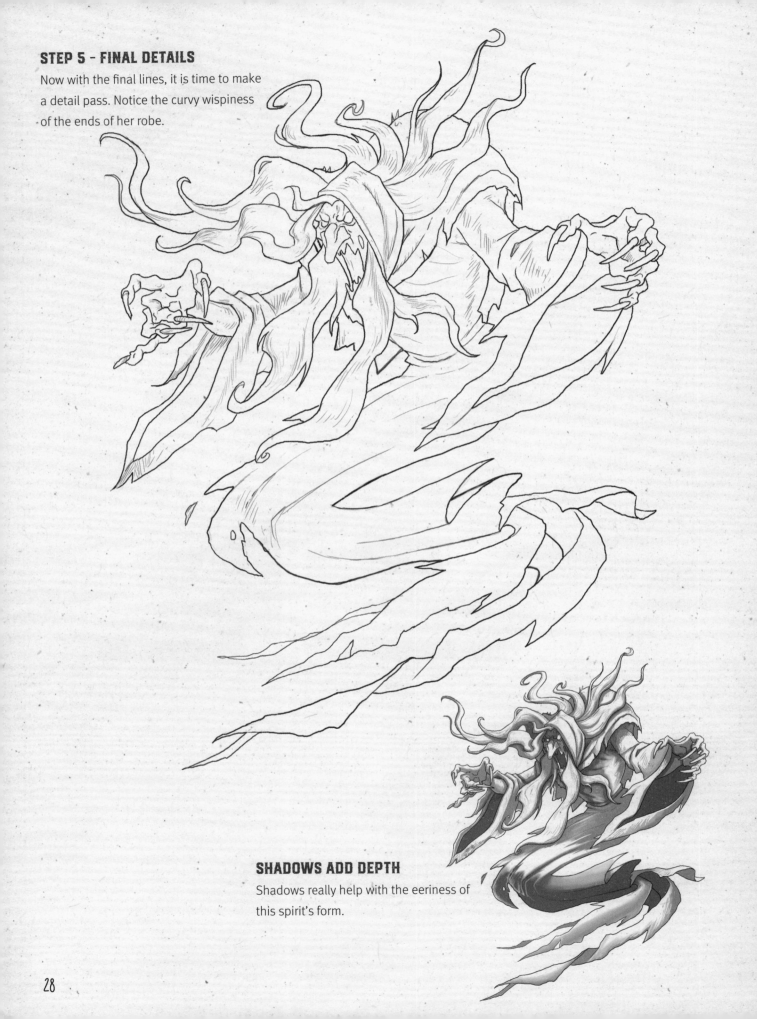

STEP 5 - FINAL DETAILS

Now with the final lines, it is time to make a detail pass. Notice the curvy wispiness of the ends of her robe.

SHADOWS ADD DEPTH

Shadows really help with the eeriness of this spirit's form.

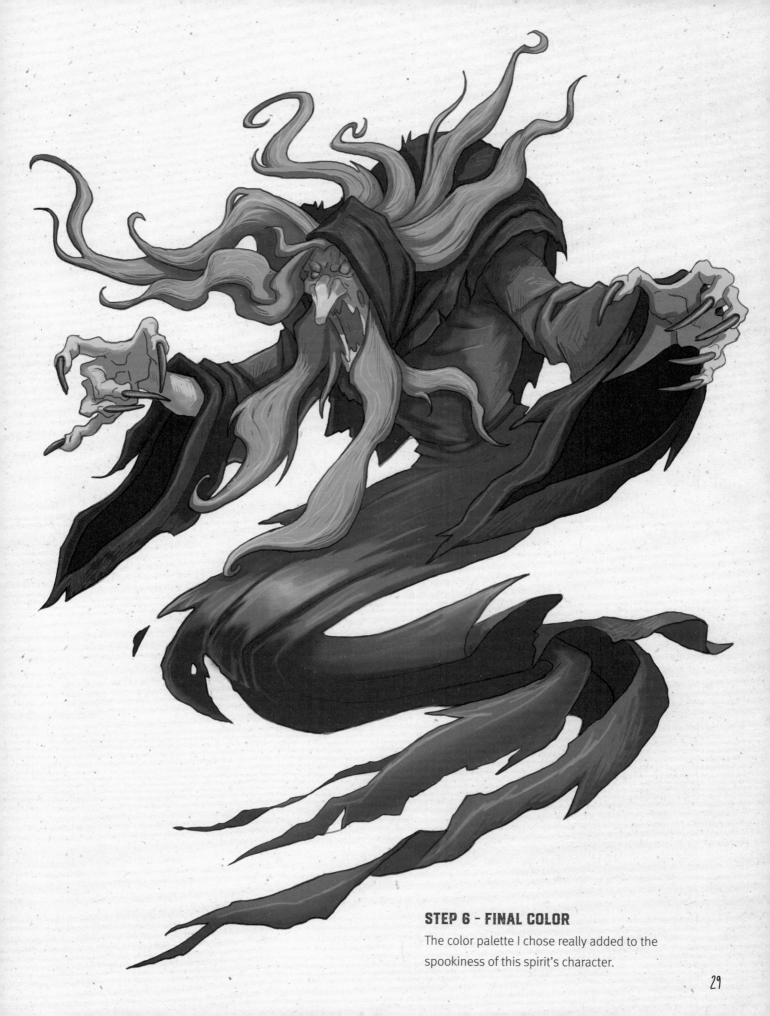

STEP 6 - FINAL COLOR
The color palette I chose really added to the
spookiness of this spirit's character.

KITSUNE

ARTIST'S NOTES:

Kitsune are known to be tricksters very similar to foxes of today's world. I wanted to add a bit of that mischievous nature to our Kitsune's expression. The little smirk and raised eyebrow area really help to push the rascally vibe of this creature.

Kitsune are shape-shifting spirits from Japanese folklore that look like foxes.

THEY ARE KNOWN FOR BEING EXTREMELY INTELLIGENT, AND POSSESS EXTRAORDINARILY LONG LIVES AND SUPERNATURAL ABILITIES.

THEY HAVE BEEN KNOWN TO SHAPE-SHIFT INTO HUMAN FORM AND EVEN BECOME CLOSE FRIENDS WITH HUMANS WHO MAY OR MAY NOT KNOW THE TRUE ORIGINS OF THEIR NEW FRIEND. OLDER KITSUNES HAVE BEEN KNOWN TO HAVE MULTIPLE TAILS, WITH THE HIGHER NUMBER OF TAILS INDICATING THE MORE ANCIENT AND POWERFUL THE KITSUNE IS.

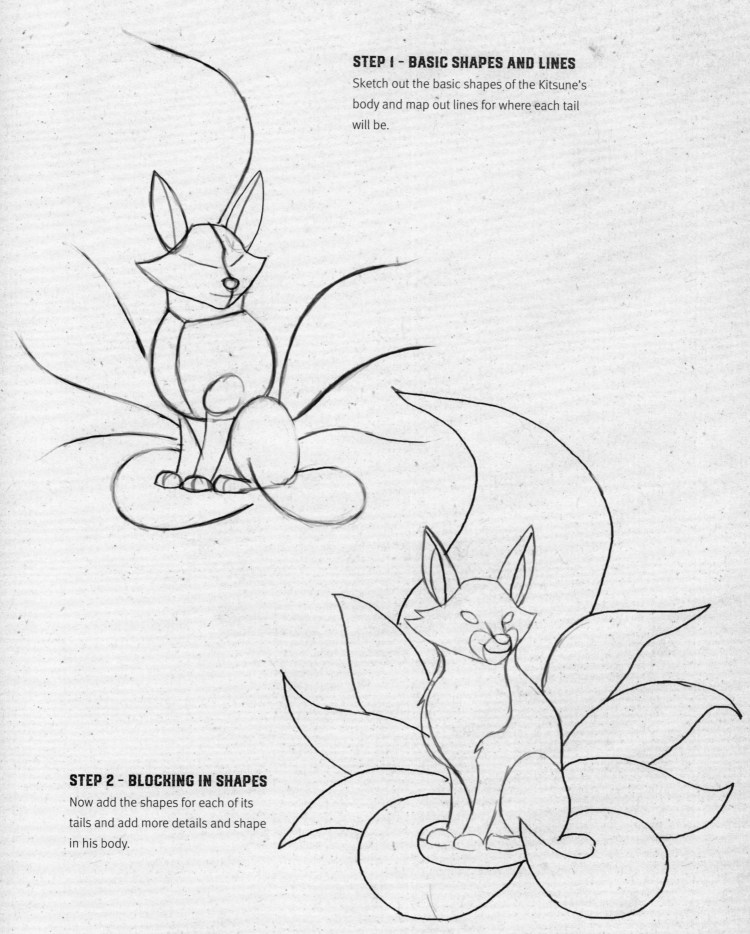

STEP 1 - BASIC SHAPES AND LINES
Sketch out the basic shapes of the Kitsune's body and map out lines for where each tail will be.

STEP 2 - BLOCKING IN SHAPES
Now add the shapes for each of its tails and add more details and shape in his body.

31

STEP 3 - ADD DETAILS

Keep adding and refining your shapes, like in the ears, muzzle, and paws.

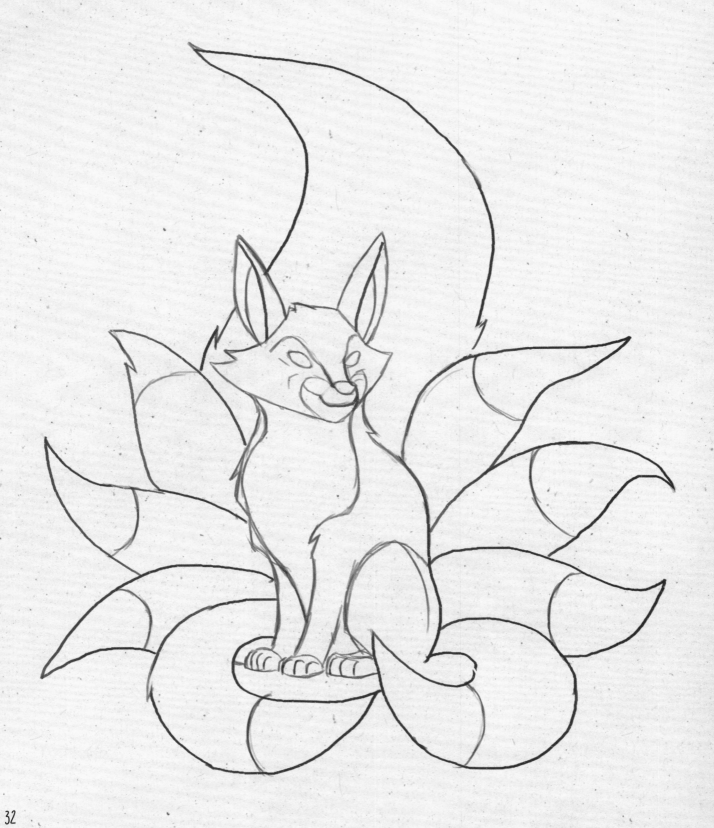

STEP 4 - CLEAN UP AND FINAL DETAILS

Add final details in his striped tails. No need to add irises in his eyes—they give off an eerie glow when colored.

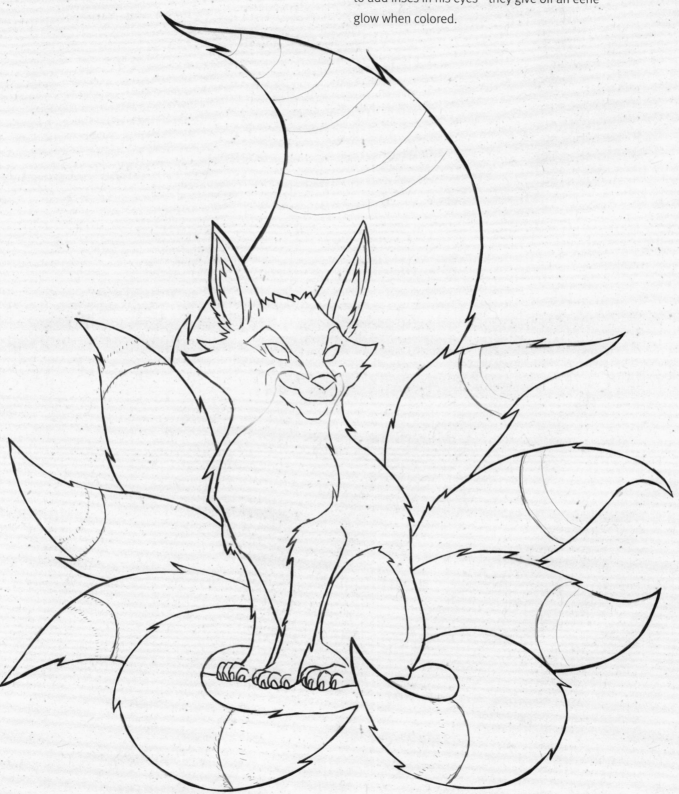

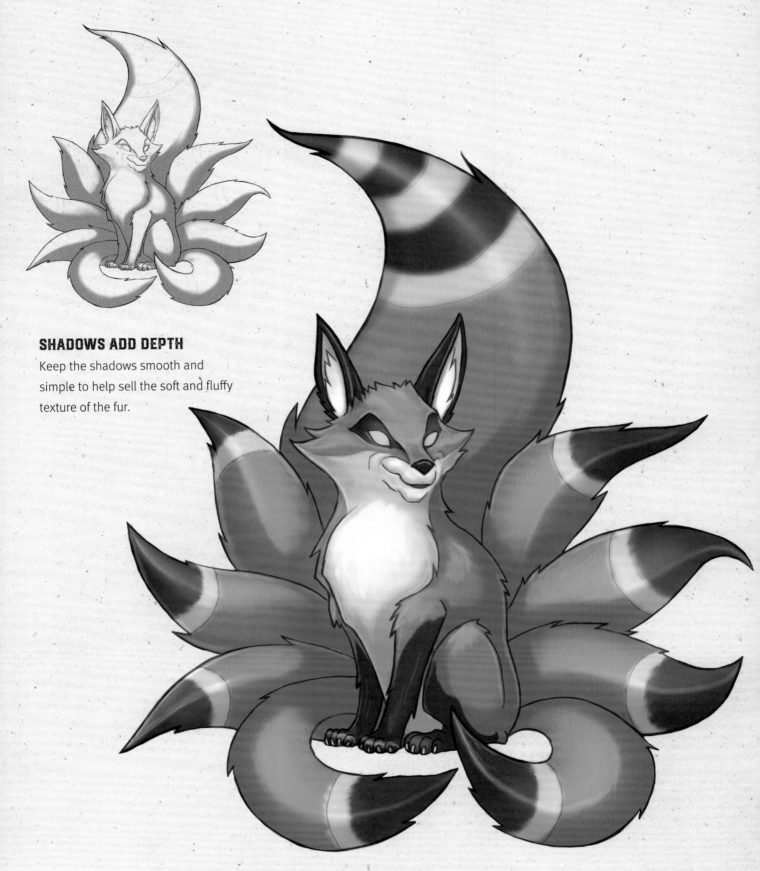

SHADOWS ADD DEPTH

Keep the shadows smooth and simple to help sell the soft and fluffy texture of the fur.

STEP 5 - FINAL COLOR

I went with the traditional coloring of a fox, with green glowing eyes.

TAKING IT TO THE NEXT LEVEL

ARTIST'S NOTES:

Some Kitsune legends are a bit darker and more sinister, so I thought I would create a version of a Kitsune that was more malevolent and evil, a shadow version of a Kitsune that may not be something you want to meet up with on a lonely road on a moonless night.

THE MOST NOTABLE THING ABOUT THE KITSUNE IS ITS COLORING AND TAILS: I ONLY WANTED TO CHANGE ONE OF THESE SO THERE WOULD BE SOMETHING FAMILIAR TO GO ALONG WITH SOMETHING NEW.

RED EYES ARE ALWAYS A GREAT WAY TO CONVEY SOMETHING IS NOT OF OUR REALM.

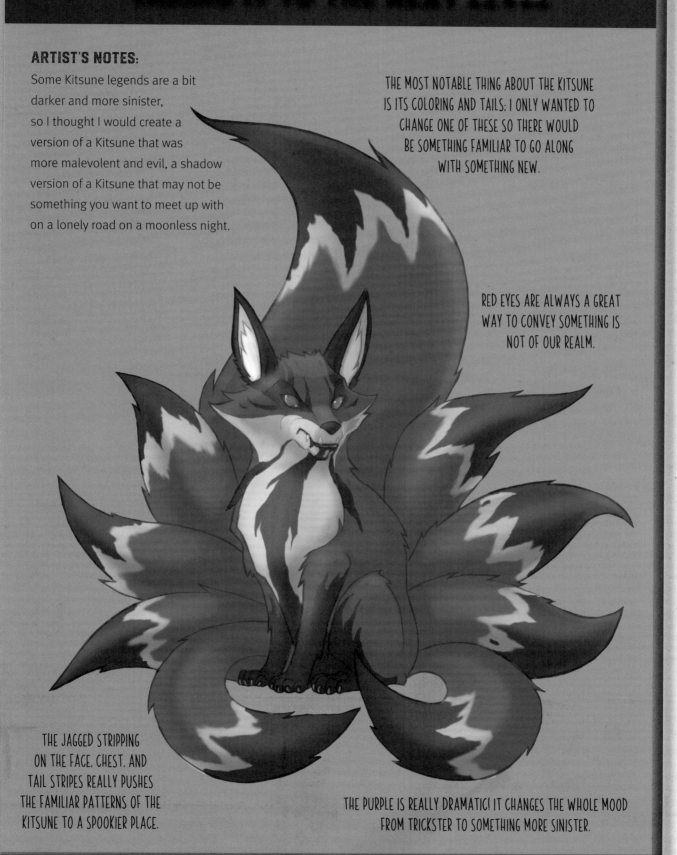

THE JAGGED STRIPPING ON THE FACE, CHEST, AND TAIL STRIPES REALLY PUSHES THE FAMILIAR PATTERNS OF THE KITSUNE TO A SPOOKIER PLACE.

THE PURPLE IS REALLY DRAMATIC! IT CHANGES THE WHOLE MOOD FROM TRICKSTER TO SOMETHING MORE SINISTER.

TOMTE

ARTIST'S NOTES:

When I was in second or third grade, I remember looking at the 1976 book *Gnomes* during our classes' free reading time. I never ended up reading all of the book, not because I wasn't interested but because I was captivated by all the beautiful artwork. Plus, the book was written in Dutch, so that didn't help.

I decided to alter the traditionally cone-shaped woolen cap to something a bit more earthly and whimsical. A hollow log looks similar in shape, but adds a bit more to his silhouette.

Around the world the Tomte is more commonly recognized as a Gnome.

TOMTES ARE USUALLY DEPICTED AS VERY SMALL BEINGS SPORTING A BIG OLD BEARD AND A BRIGHTLY COLORED CAP, USUALLY RED.

TOMTES HAVE BEEN PART OF SCANDINAVIAN FOLKLORE FOR CENTURIES AND WERE KNOWN TO HELP OUT A FARMSTEAD AND EVEN PROTECT IT FROM DANGER. IN RETURN, THE FARMER AND FAMILY WILL SET OUT FOOD FOR THE TOMTE IN GRATITUDE. BUT BE WARNED, IF PROPER RESPECT IS NOT SHOWN, THE TOMTE CAN TURN VERY MISCHIEVOUS AND CAUSE ALL SORTS OF TROUBLE AROUND THE FARMSTEAD.

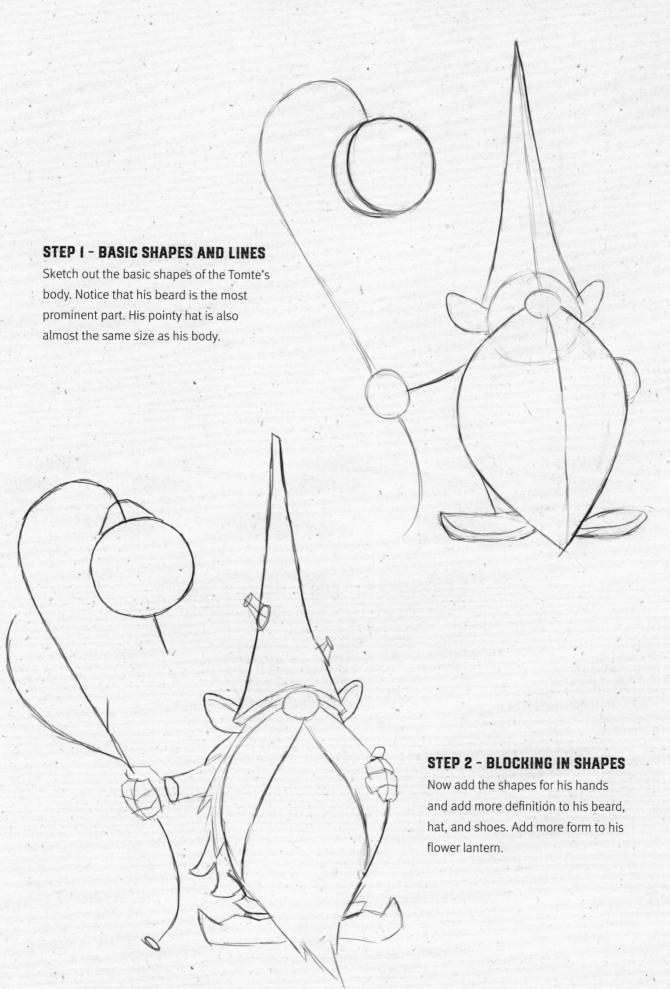

STEP 1 - BASIC SHAPES AND LINES

Sketch out the basic shapes of the Tomte's body. Notice that his beard is the most prominent part. His pointy hat is also almost the same size as his body.

STEP 2 - BLOCKING IN SHAPES

Now add the shapes for his hands and add more definition to his beard, hat, and shoes. Add more form to his flower lantern.

37

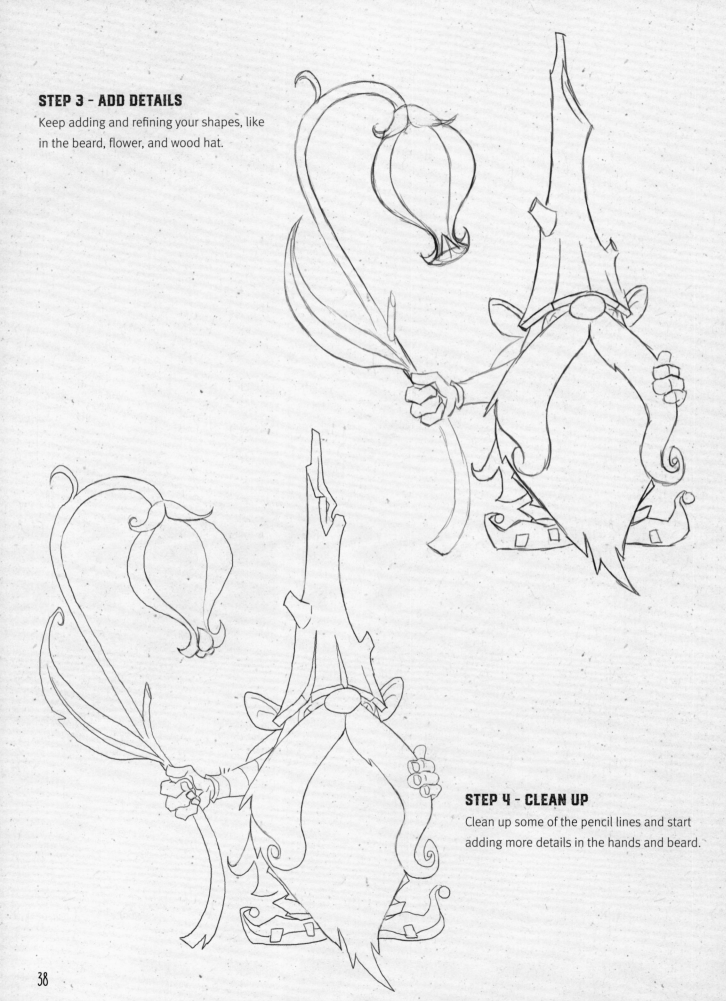

STEP 3 - ADD DETAILS

Keep adding and refining your shapes, like in the beard, flower, and wood hat.

STEP 4 - CLEAN UP

Clean up some of the pencil lines and start adding more details in the hands and beard.

STEP 5 - FINAL DETAILS

Add definition to the wood grain in his hat and the flower.

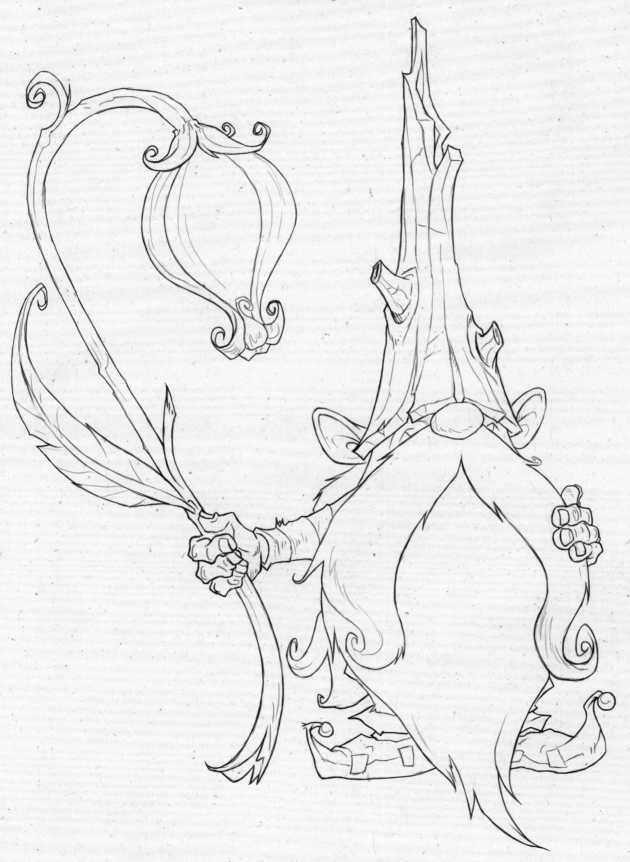

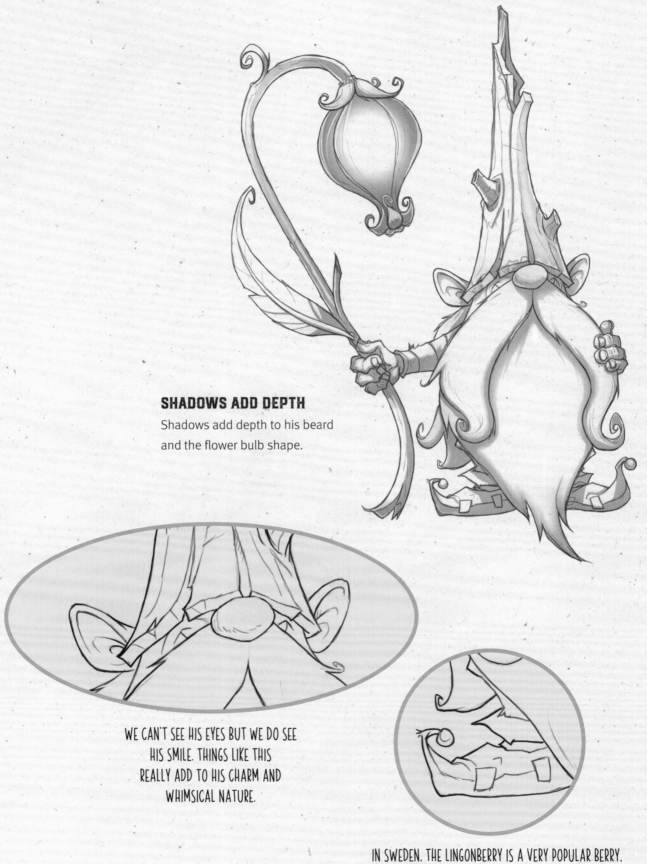

SHADOWS ADD DEPTH

Shadows add depth to his beard and the flower bulb shape.

WE CAN'T SEE HIS EYES BUT WE DO SEE HIS SMILE. THINGS LIKE THIS REALLY ADD TO HIS CHARM AND WHIMSICAL NATURE.

IN SWEDEN. THE LINGONBERRY IS A VERY POPULAR BERRY. AND I ADDED A FEW OF THESE TO OUR TOMTE'S LITTLE BOOTIES. THIS. ALONG WITH HIS FLOWER LANTERN. REALLY PUSHES OUR TOMTE'S DIMINUTIVE NATURE.

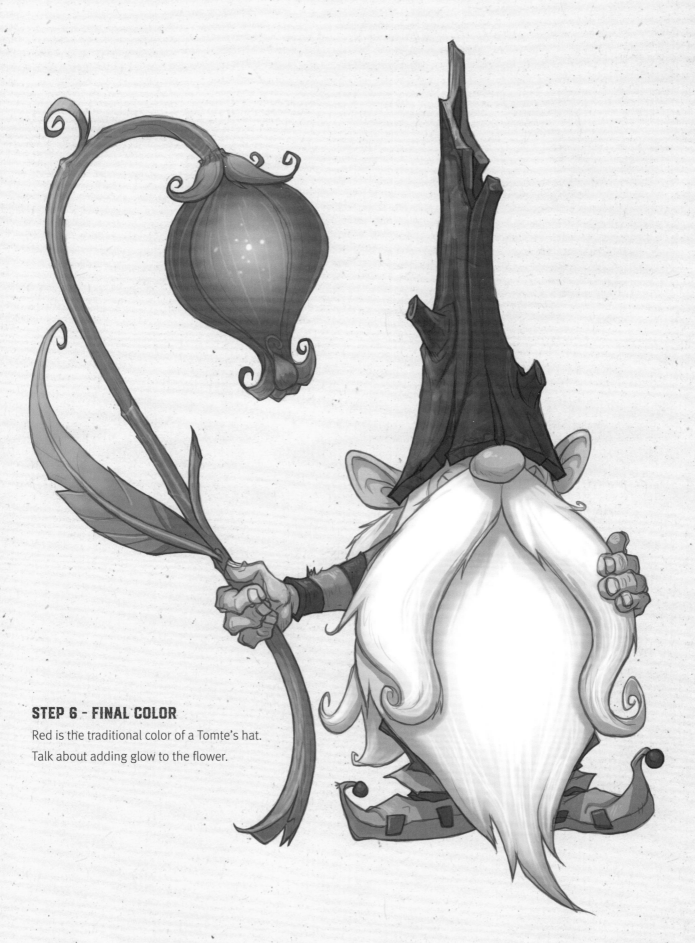

STEP 6 - FINAL COLOR

Red is the traditional color of a Tomte's hat.
Talk about adding glow to the flower.

FAIRY

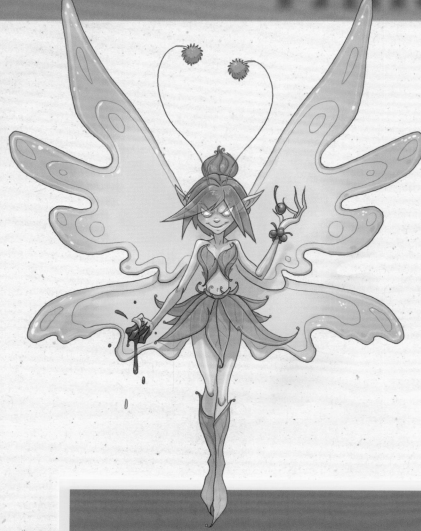

ARTIST'S NOTES:

I wanted to create this Fairy with a hint of mischief about her. Outwardly she appears very much the normal Fairy, but there is a glint of trouble in her eyes.

If you ever see a ring of mushrooms on your lawn or out in the woods, be warned. These are known as "Fairy rings" and are thought to be places where Fairies gather.

One of the artists who has devoted decades to the painting (and capturing) of Fairies is Brian Froud. His artwork has inspired countless artists and introduced many people to the magical world of Fairies.

The term "Fairy" is often used to describe any number of tiny beings. They are usually humanoid in appearance, and they are generally known to cause mischief.

FOR CENTURIES, WE HAVE BEEN CAPTIVATED BY THE DIMINUTIVE BEINGS KNOWN AS FAIRIES
AND ALL THE LORE SURROUNDING THEM.

TODAY, I WOULD SAY THE MAIN IMAGE THAT RESONATES WITH MOST PEOPLE
IS THE SMALL, USUALLY FEMALE FAIRY WITH BUTTERFLY WINGS.

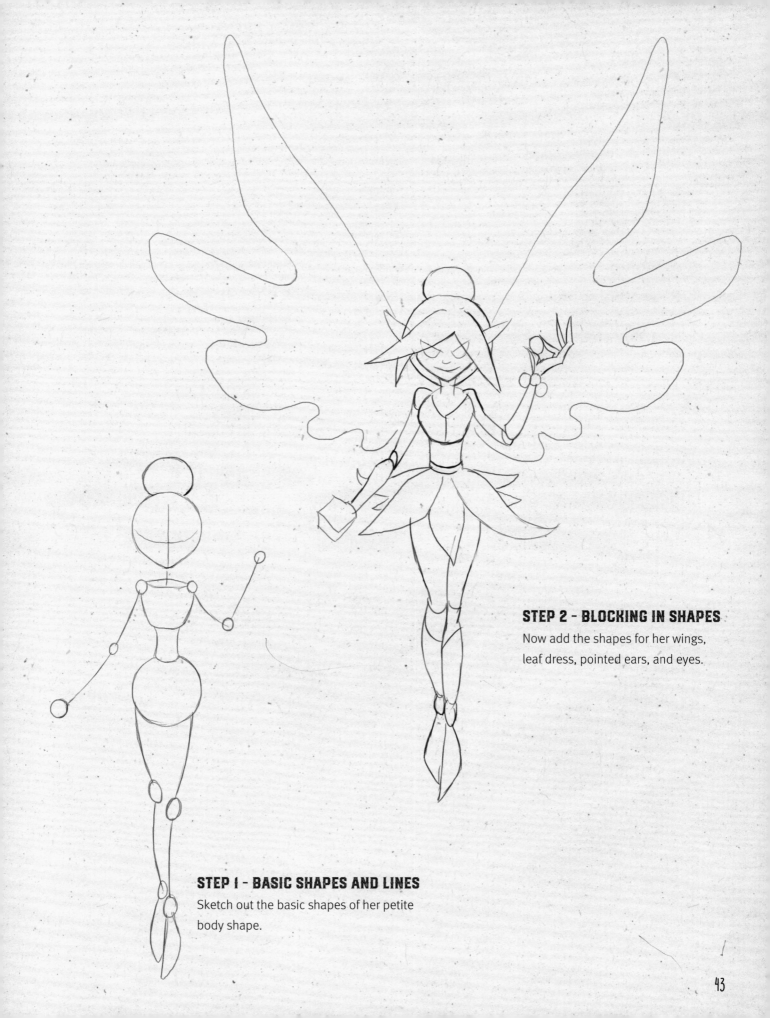

STEP 2 - BLOCKING IN SHAPES

Now add the shapes for her wings, leaf dress, pointed ears, and eyes.

STEP 1 - BASIC SHAPES AND LINES

Sketch out the basic shapes of her petite body shape.

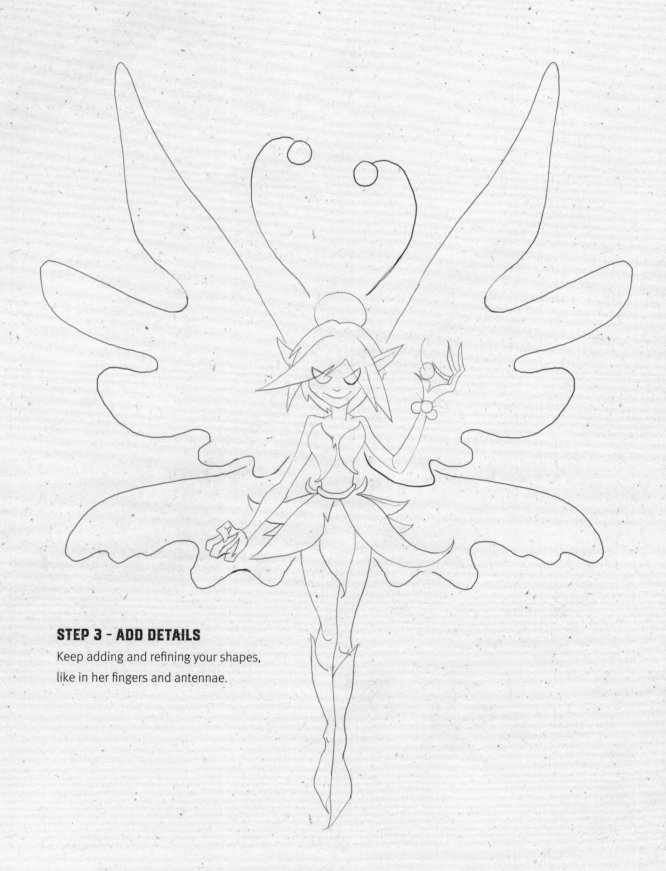

STEP 3 - ADD DETAILS
Keep adding and refining your shapes,
like in her fingers and antennae.

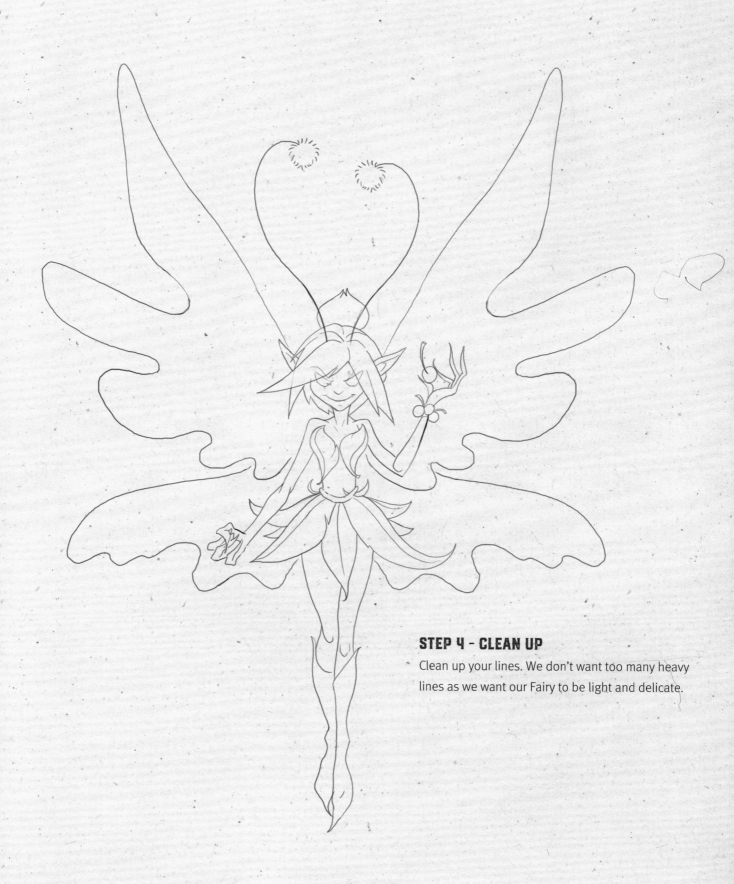

STEP 4 - CLEAN UP

Clean up your lines. We don't want too many heavy
lines as we want our Fairy to be light and delicate.

SHADOWS ADD DEPTH

Keep the shadows smooth and simple to define the delicate wing shapes.

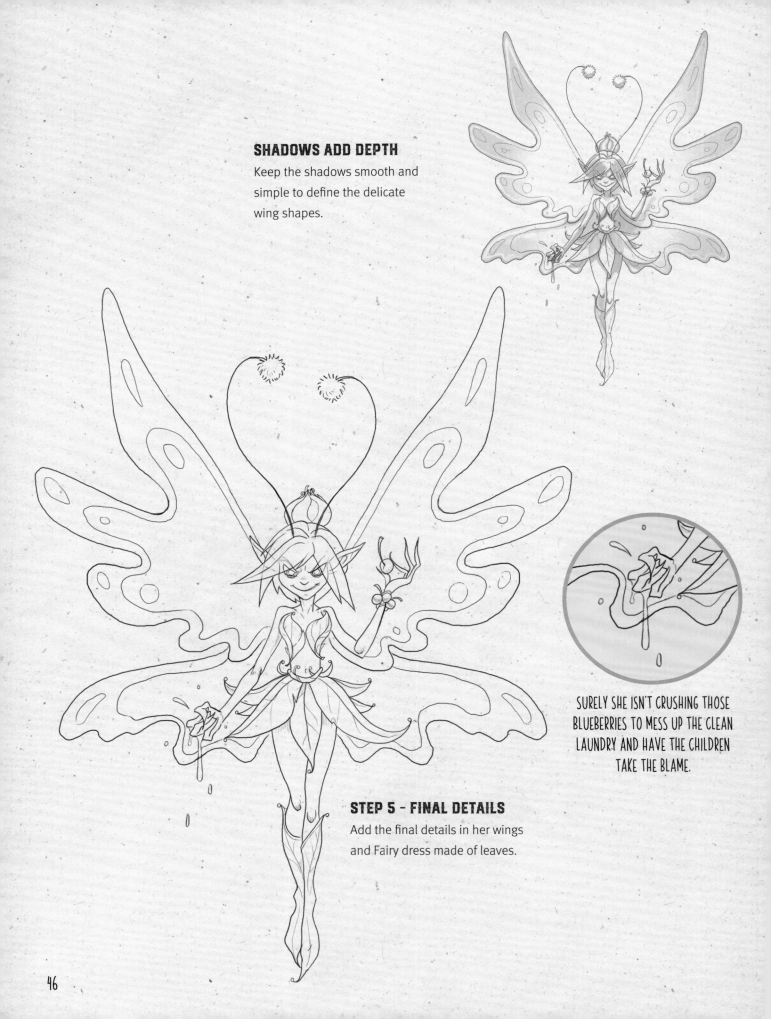

STEP 5 - FINAL DETAILS

Add the final details in her wings and Fairy dress made of leaves.

SURELY SHE ISN'T CRUSHING THOSE BLUEBERRIES TO MESS UP THE CLEAN LAUNDRY AND HAVE THE CHILDREN TAKE THE BLAME.

STEP 6 – FINAL COLOR

The color palette I chose really added to the spookiness of this spirit's character.

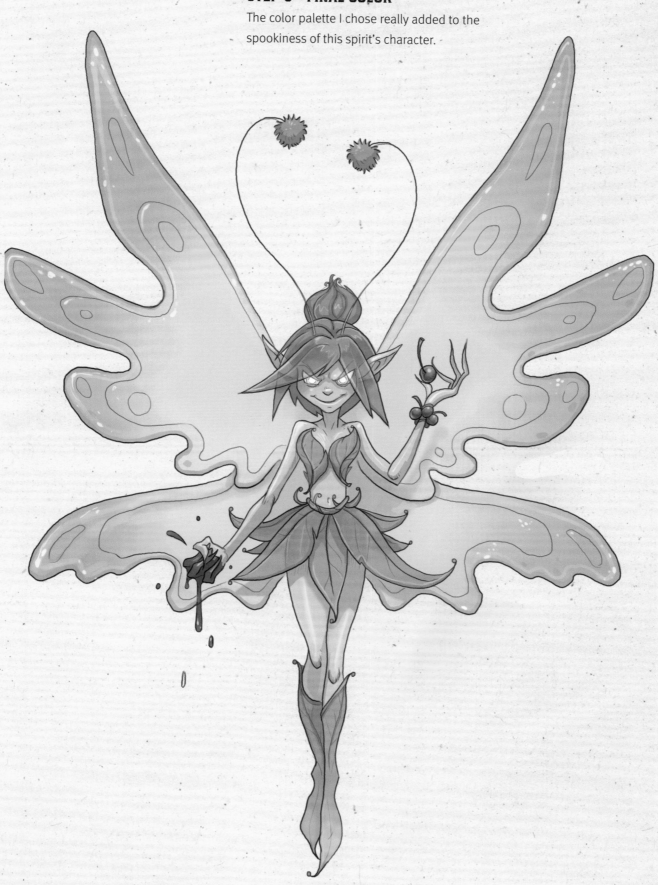

JINN

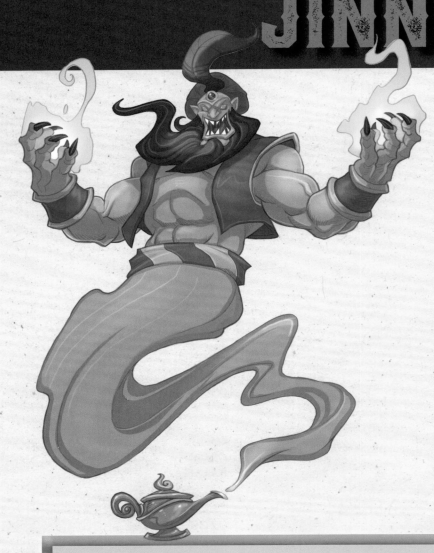

ARTIST'S NOTES:

Most people's knowledge of the Jinn comes from more modern literature, like the *One Thousand and One Nights* collection of tales and other, more recent interpretations. In fact, the origins of the Jinn can be traced back more than a thousand years.

The Ifrit is often associated with the Jinn, but has a much darker and malevolent side. It has the power to shape-shift into an exotic creature and even turn into living fire. After we draw the Jinn, I want to show you that with a few tweaks to the artwork and a change of color, you can change your Jinn into an infernal Ifrit!

The more common word we use for the Jinn in pop culture is "Genie."

IN FOLK LITERATURE, JINNS ARE SUPERNATURAL BEINGS WHO POSSESS INCREDIBLE POWERS AND ABILITIES. JINNS HAVE BEEN BOTH HELPFUL AS WELL AS DANGEROUS TO THE MORTAL PEOPLE THEY ENCOUNTER.

STORIES HAVE BEEN TOLD OF JINNS BEING ABLE TO GRANT WISHES TO THE PERSON RELEASING THEM FROM IMPRISONMENT, AND THEY ALSO HAVE OTHER MAGICAL ABILITIES SUCH AS TELEPORTATION AND FLIGHT.

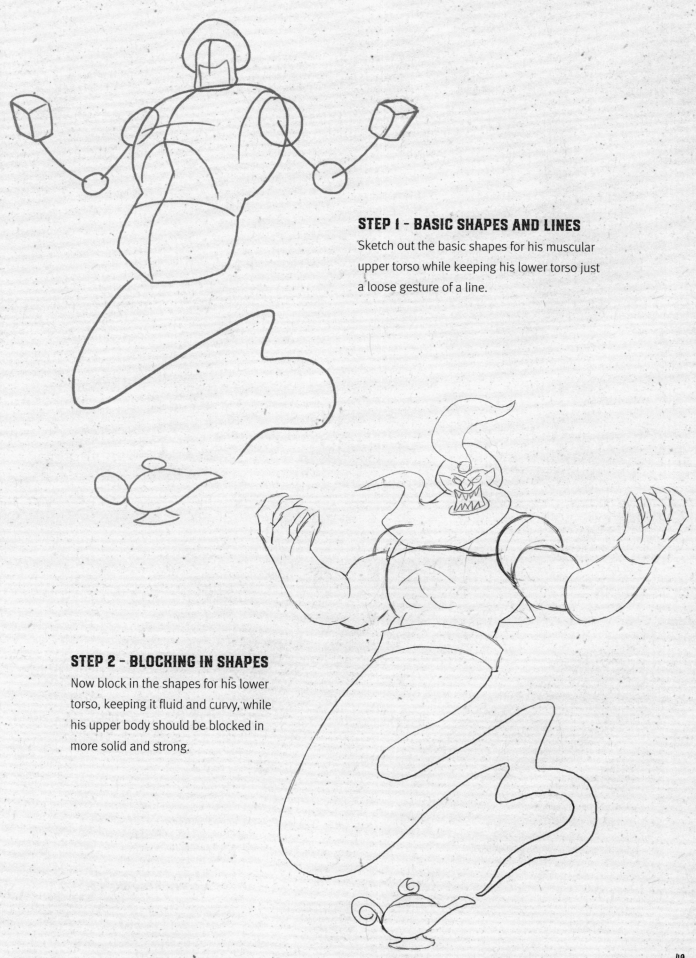

STEP 1 - BASIC SHAPES AND LINES

Sketch out the basic shapes for his muscular upper torso while keeping his lower torso just a loose gesture of a line.

STEP 2 - BLOCKING IN SHAPES

Now block in the shapes for his lower torso, keeping it fluid and curvy, while his upper body should be blocked in more solid and strong.

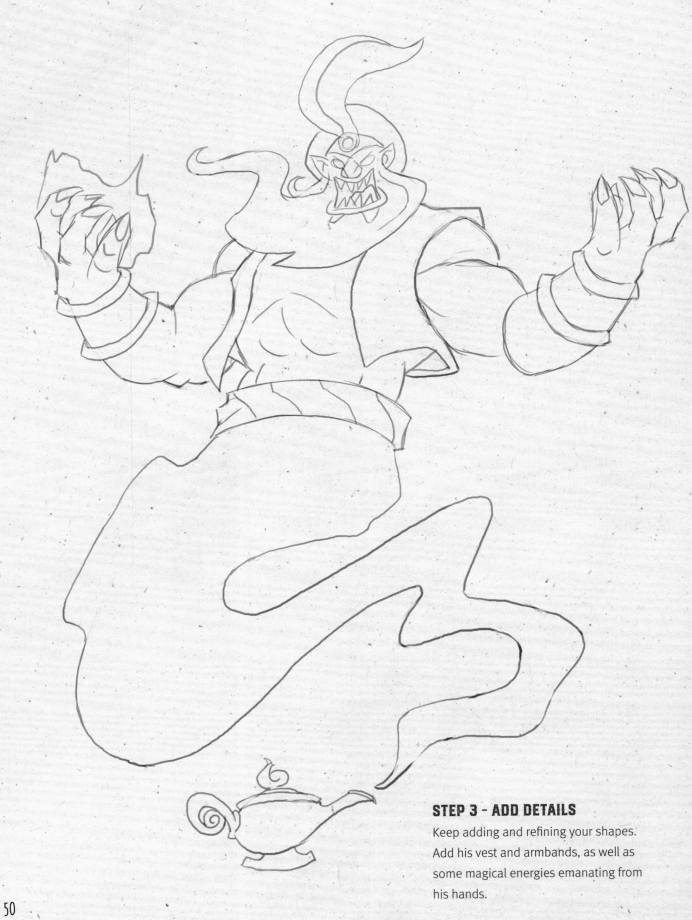

STEP 3 - ADD DETAILS

Keep adding and refining your shapes. Add his vest and armbands, as well as some magical energies emanating from his hands.

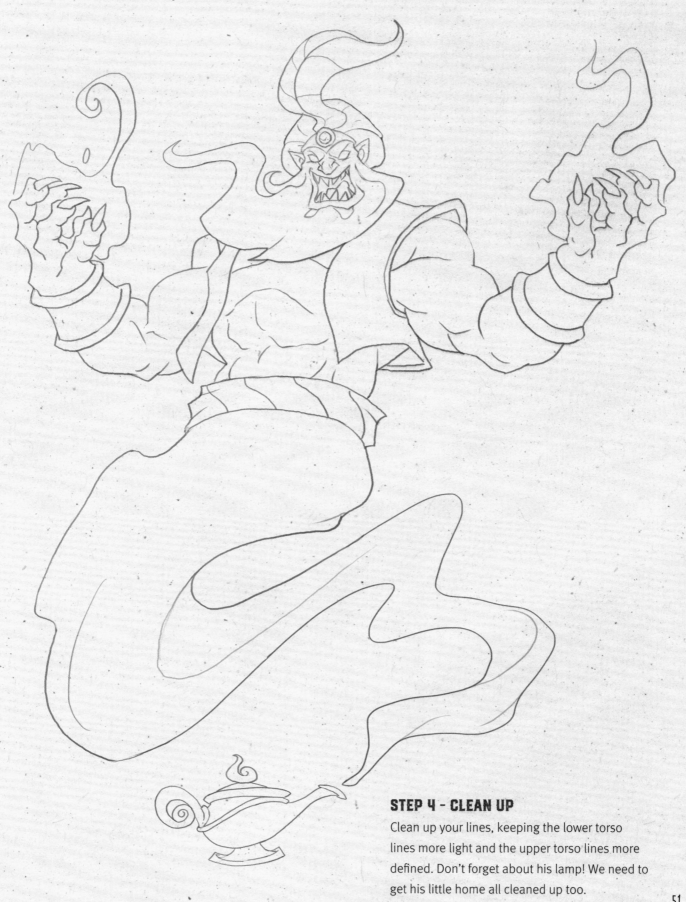

STEP 4 - CLEAN UP

Clean up your lines, keeping the lower torso lines more light and the upper torso lines more defined. Don't forget about his lamp! We need to get his little home all cleaned up too.

STEP 5 - FINAL DETAILS

To show his upper torso is more tangible than his lower torso, give the chest, head, and arm area a darker pencil line around them, while keeping the lower torso lines still thin and light.

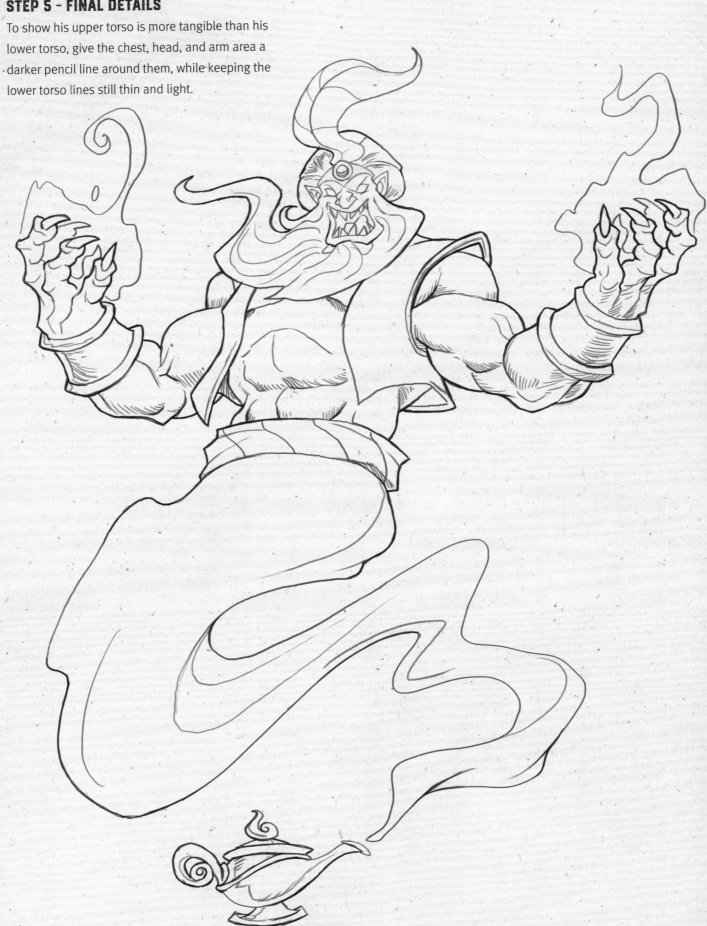

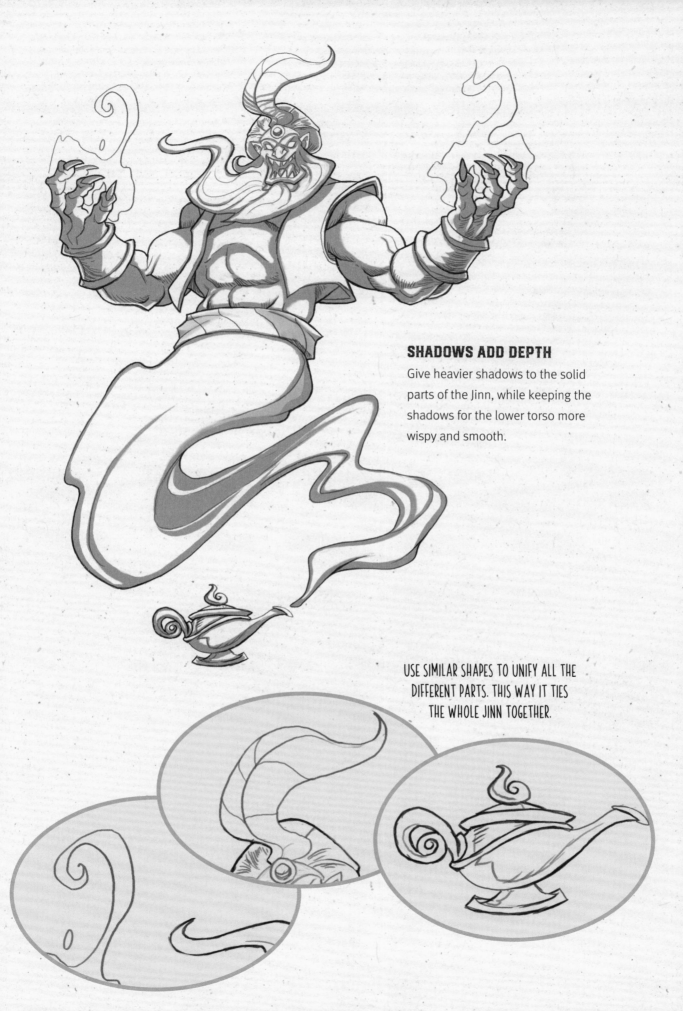

SHADOWS ADD DEPTH

Give heavier shadows to the solid parts of the Jinn, while keeping the shadows for the lower torso more wispy and smooth.

USE SIMILAR SHAPES TO UNIFY ALL THE DIFFERENT PARTS. THIS WAY IT TIES THE WHOLE JINN TOGETHER.

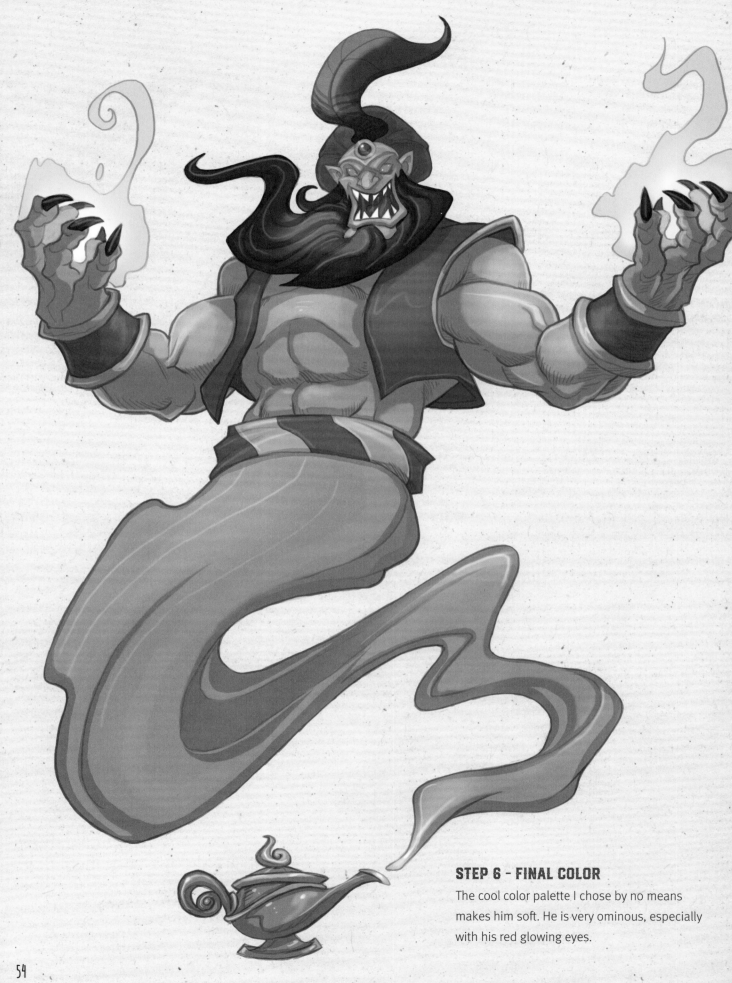

STEP 6 - FINAL COLOR

The cool color palette I chose by no means makes him soft. He is very ominous, especially with his red glowing eyes.

TAKING IT TO THE NEXT LEVEL

SIMPLE COLOR CHANGES CAN REALLY HELP PUSH THE LOOK OF AN IMAGE.

I SWAPPED HIS NORMAL BEARD AND MADE IT A FIERY ONE.

INSTEAD OF MAGIC IN HIS HANDS, I ADDED FLAMES TO MATCH THE BEARD.

SO WITH JUST A DIFFERENT COLOR SCHEME AND A FEW MINOR ART TWEAKS, WE HAVE CREATED A WHOLE NEW CREATURE!

MEDUSA

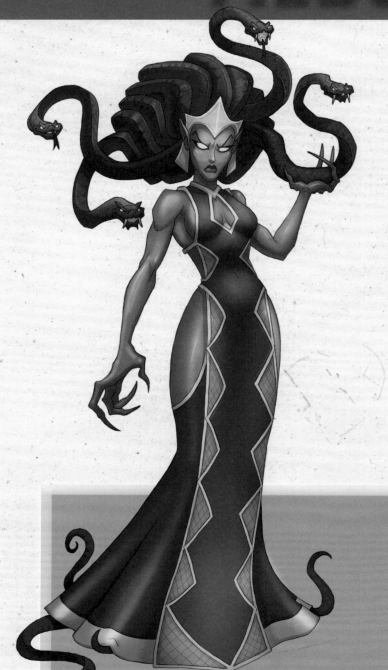

ARTIST'S NOTES:

Artists over the centuries have represented Medusa in many different ways; some were horrific monsters while others were normal-looking women.

The 1981 movie *Clash of the Titans* had the best-looking Medusa I have ever seen. This Medusa has a cruel and scary face, with the upper body of a woman and the lower torso of a rattlesnake, complete with rattle and all! She slithered around the ruins and used a bow and arrow to take out enemies from afar, while her terrifying gaze took care of any enemies that got too close to her. Well, all except for one.

I wanted to do something a little different for my interpretation of Medusa. Instead of the monstrous creature of mythology, I pushed mine toward a lethal and elegant Medusa.

Medusa the Gorgon was a monster from Greek mythology.

MEDUSA HAS BEEN DESCRIBED AS A HIDEOUS MONSTER IN SOME MYTHS, BUT ALSO AS A STATUESQUE WOMAN OF BEAUTY. ONE THING THAT ALL THE MYTHS CAN AGREE ON IS THIS: WHILE SHE HAD THE BODY OF A HUMAN, HER HAIR WAS A TANGLE OF WRITHING, VENOMOUS SNAKES.

AND, IF THAT WASN'T SCARY ENOUGH, TO GAZE UPON MEDUSA WOULD CAUSE THE LOOKER TO TURN TO STONE!

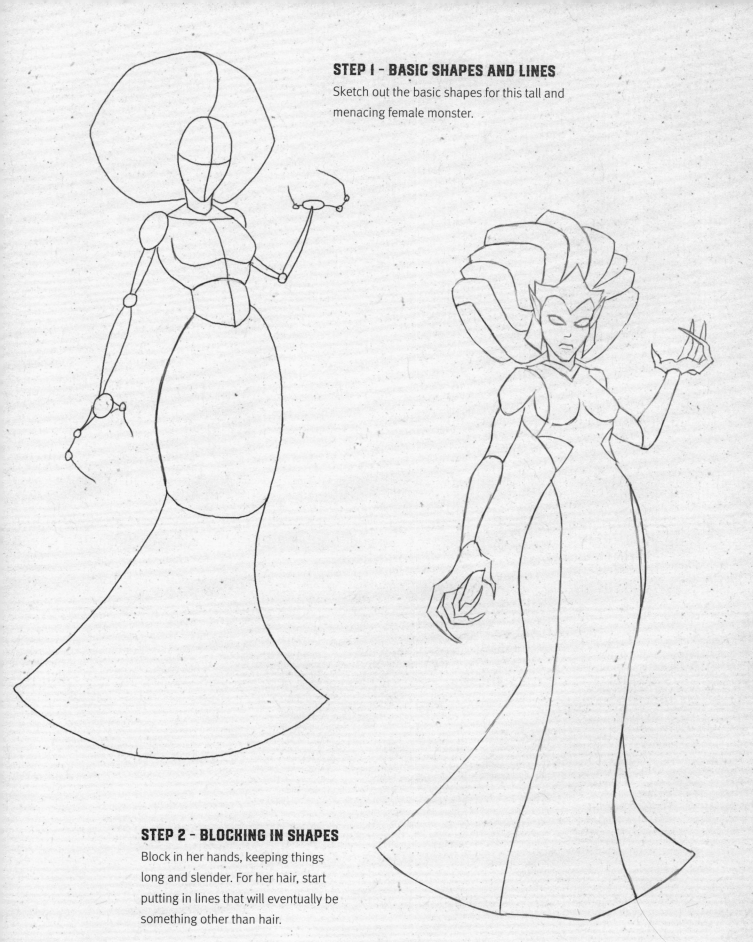

STEP 1 - BASIC SHAPES AND LINES

Sketch out the basic shapes for this tall and menacing female monster.

STEP 2 - BLOCKING IN SHAPES

Block in her hands, keeping things long and slender. For her hair, start putting in lines that will eventually be something other than hair.

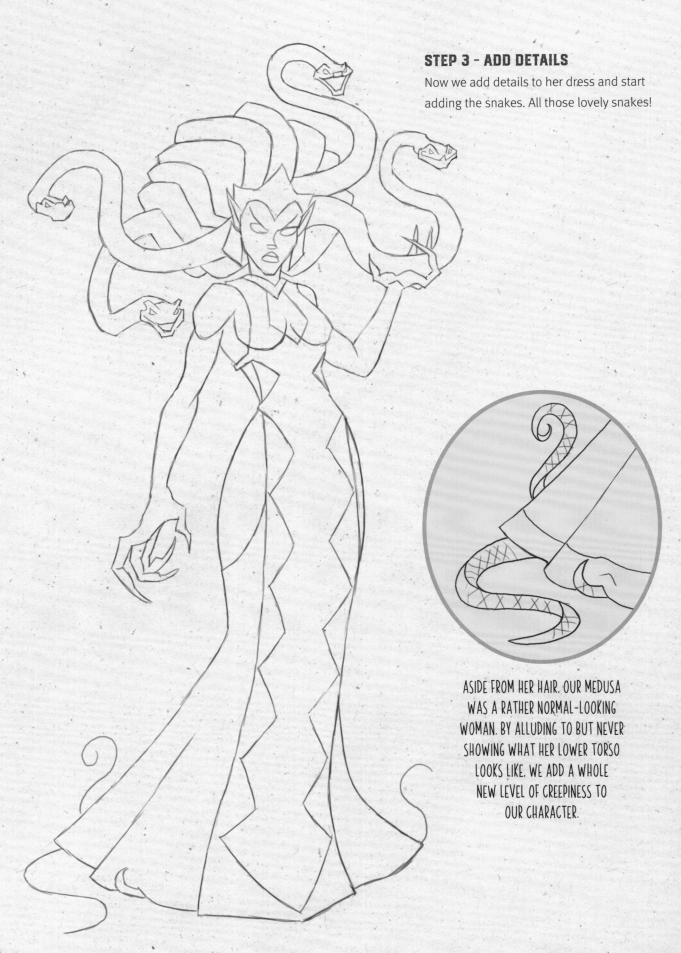

STEP 3 - ADD DETAILS
Now we add details to her dress and start adding the snakes. All those lovely snakes!

ASIDE FROM HER HAIR, OUR MEDUSA WAS A RATHER NORMAL-LOOKING WOMAN. BY ALLUDING TO BUT NEVER SHOWING WHAT HER LOWER TORSO LOOKS LIKE, WE ADD A WHOLE NEW LEVEL OF CREEPINESS TO OUR CHARACTER.

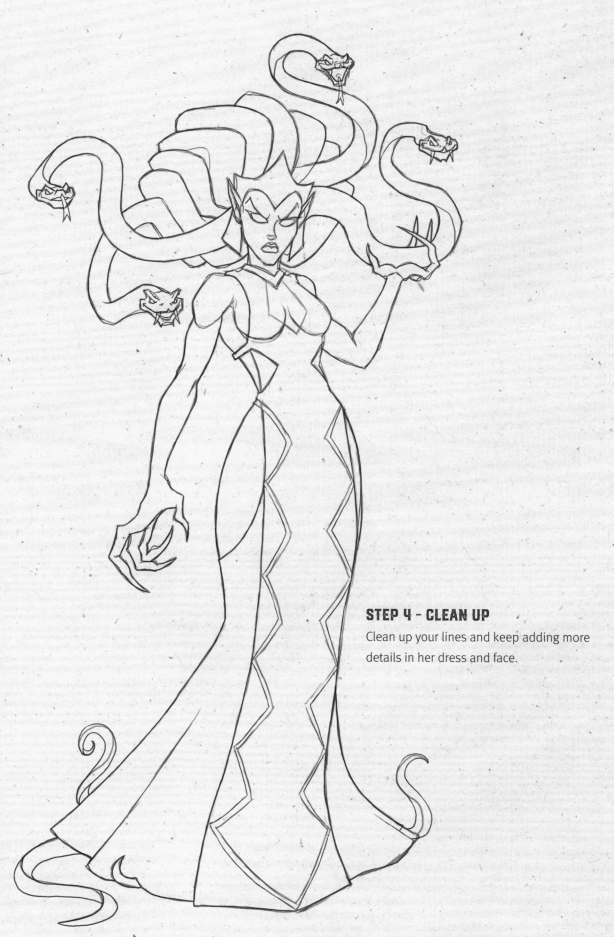

STEP 4 - CLEAN UP

Clean up your lines and keep adding more details in her dress and face.

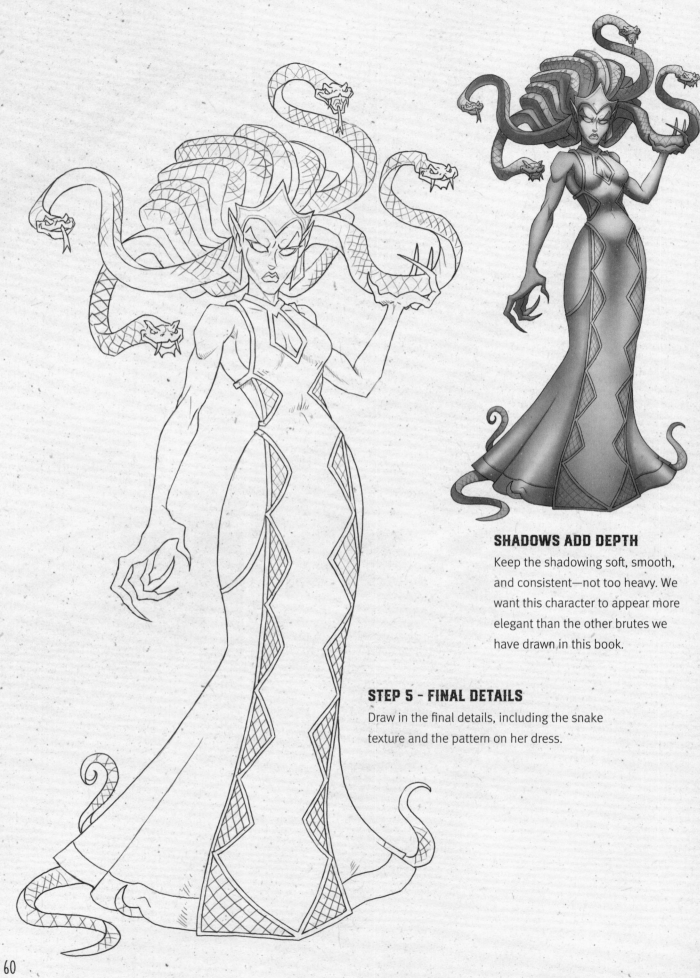

SHADOWS ADD DEPTH

Keep the shadowing soft, smooth, and consistent—not too heavy. We want this character to appear more elegant than the other brutes we have drawn in this book.

STEP 5 - FINAL DETAILS

Draw in the final details, including the snake texture and the pattern on her dress.

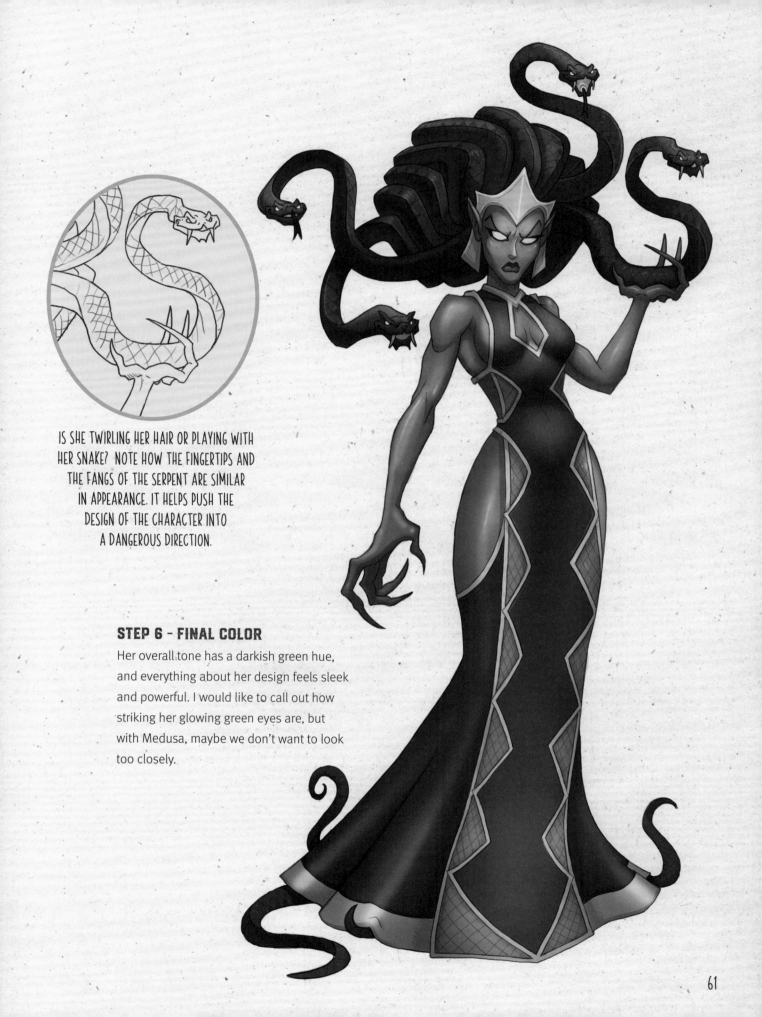

IS SHE TWIRLING HER HAIR OR PLAYING WITH
HER SNAKE? NOTE HOW THE FINGERTIPS AND
THE FANGS OF THE SERPENT ARE SIMILAR
IN APPEARANCE. IT HELPS PUSH THE
DESIGN OF THE CHARACTER INTO
A DANGEROUS DIRECTION.

STEP 6 - FINAL COLOR

Her overall tone has a darkish green hue,
and everything about her design feels sleek
and powerful. I would like to call out how
striking her glowing green eyes are, but
with Medusa, maybe we don't want to look
too closely.

SELKIE

ARTIST'S NOTES:

Selkie stories are found throughout many countries, and tales of these shape-shifters have been found in places like Ireland, Iceland, and the Faroe Islands.

Tales have been told of cruel land-dwellers stealing the sealskin and forcing the Selkie to work for them. Thankfully, most of the stories usually end with the Selkie finding her sealskin and returning to the sea.

Selkies have also been associated with other mythical creatures like mermaids, kelpies, and merrows.

IN SCOTTISH LORE, THE SELKIE IS A MAGICAL CREATURE THAT HAS THE APPEARANCE OF A NORMAL SEAL BUT HAS THE ABILITY TO REMOVE ITS SKIN AND CHANGE INTO A HUMAN. WHILE THERE ARE SOME TALES THAT TELL OF SELKIES BEING MALE, THE MAJORITY OF FOLK TALES TEND TO PORTRAY THEM AS FEMALE.

STORIES HAVE BEEN TOLD OF HOW THE SELKIE WILL COME ON SHORE, REMOVE THEIR SEALSKIN, AND PLAYFULLY DANCE IN THE MOONLIGHT.

STEP 1 - BASIC SHAPES AND LINES

Let's start by blocking out our Selkie as well as a rock she is perched on.

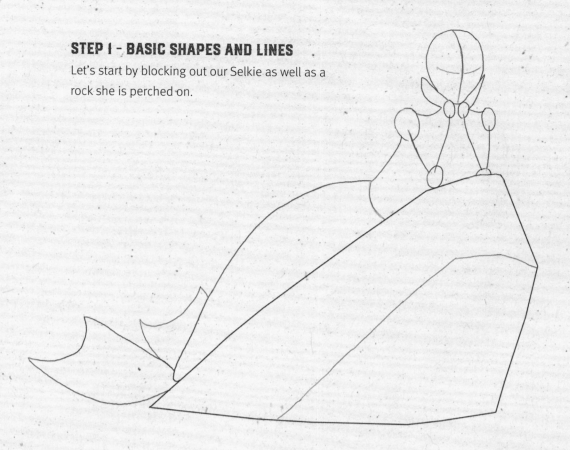

STEP 2 - BLOCKING IN SHAPES

Now add some volume and shape to her hair and some basic facial features.

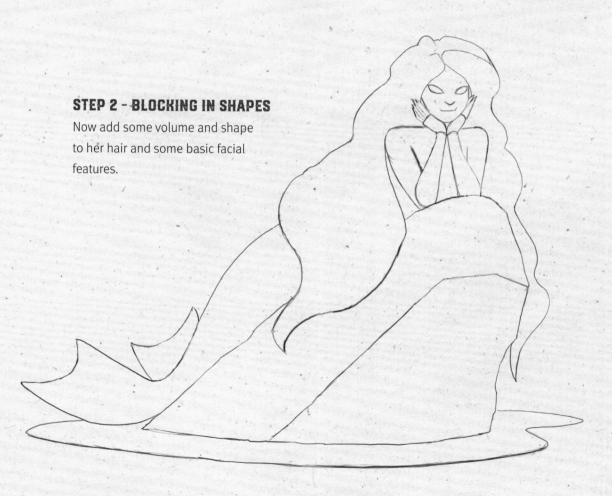

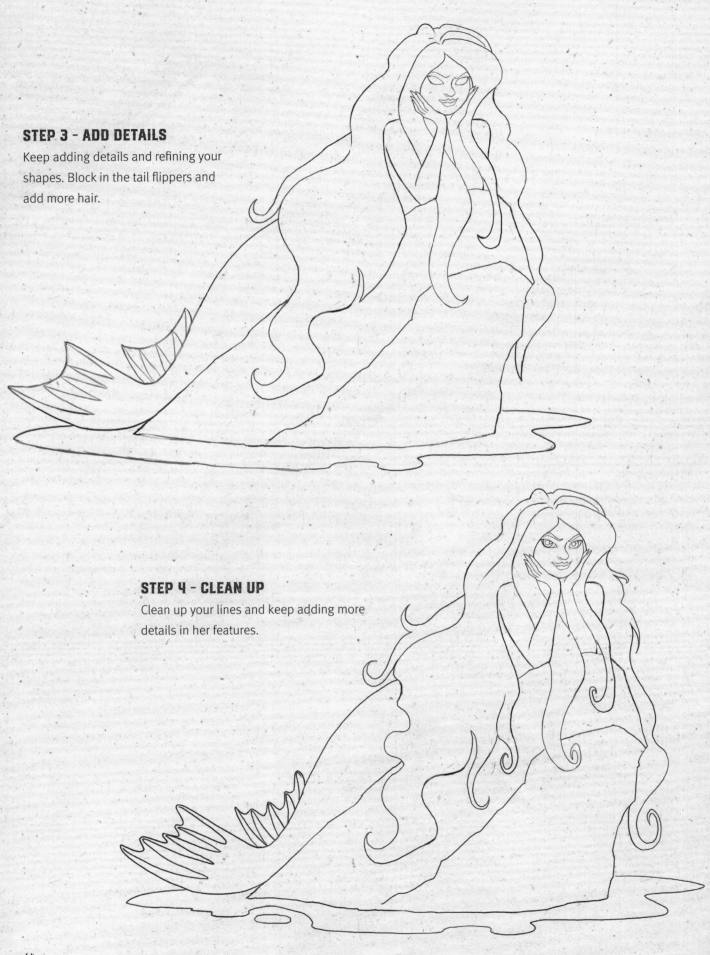

STEP 3 - ADD DETAILS

Keep adding details and refining your shapes. Block in the tail flippers and add more hair.

STEP 4 - CLEAN UP

Clean up your lines and keep adding more details in her features.

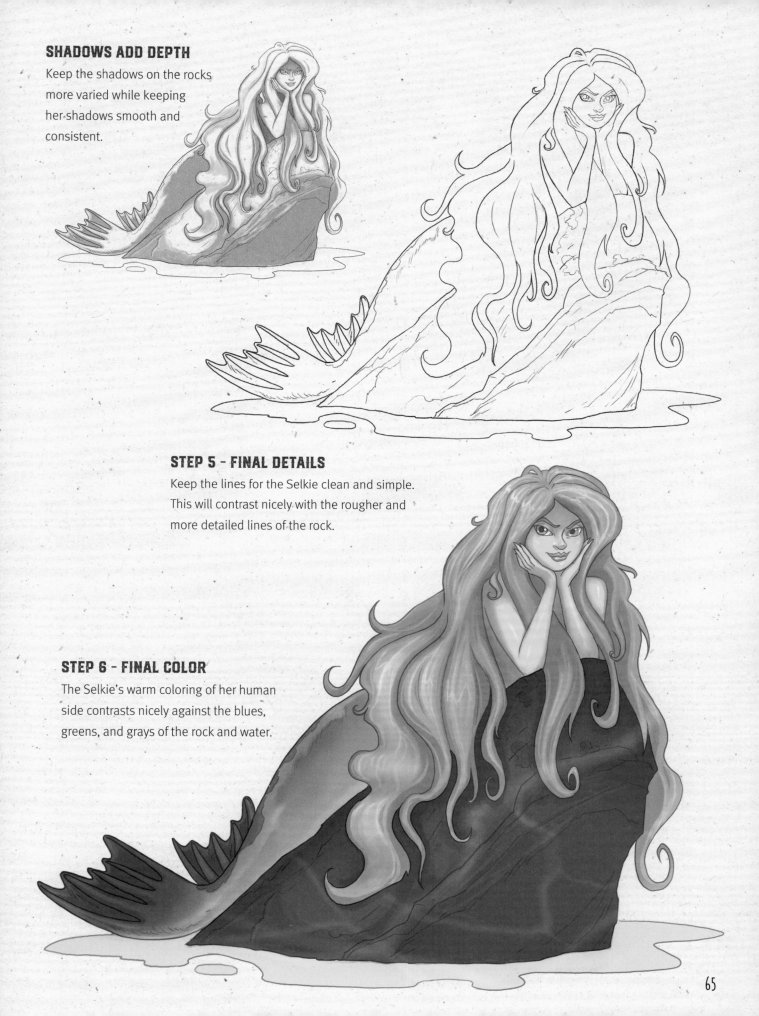

SHADOWS ADD DEPTH

Keep the shadows on the rocks more varied while keeping her shadows smooth and consistent.

STEP 5 – FINAL DETAILS

Keep the lines for the Selkie clean and simple. This will contrast nicely with the rougher and more detailed lines of the rock.

STEP 6 – FINAL COLOR

The Selkie's warm coloring of her human side contrasts nicely against the blues, greens, and grays of the rock and water.

MANTICORE

ARTIST'S NOTES:

I was first introduced to the Manticore, as well as many other creatures in this book, when I was a boy and started playing Dungeons and Dragons with my friends. Though I never had a chance to fight one of these bad boys over the years, I always thought that these creatures were some of the coolest monsters in the world.

Some myths describe them as having the body of a tiger instead of a lion, and even boasting boar tusks and horns! I think that just made something already monstrous into something completely terrifying!

The Manticore is a creature from Persian mythology said to have the body of a lion and the head of a man.

THE MANTICORE'S TAIL IS FULL OF VENOMOUS SPIKES, WHICH THE MANTICORE CAN HURL LIKE JAVELINS AT HIS FLEEING PREY. SOME DESCRIPTIONS EVEN HAVE THEM WITH LEATHERY WINGS LIKE THAT OF A DRAGON.

THE MANTICORE IS A VORACIOUSLY HUNGRY BEAST KNOWN TO DEVOUR ITS VICTIMS WHOLE-ARMOR, WEAPONS, CLOTHES, AND ALL! OF ALL THE CREATURES IN THIS BOOK, SURELY THIS IS ONE OF THE MOST FEARSOME AND SCARY . . . LET'S DRAW IT!

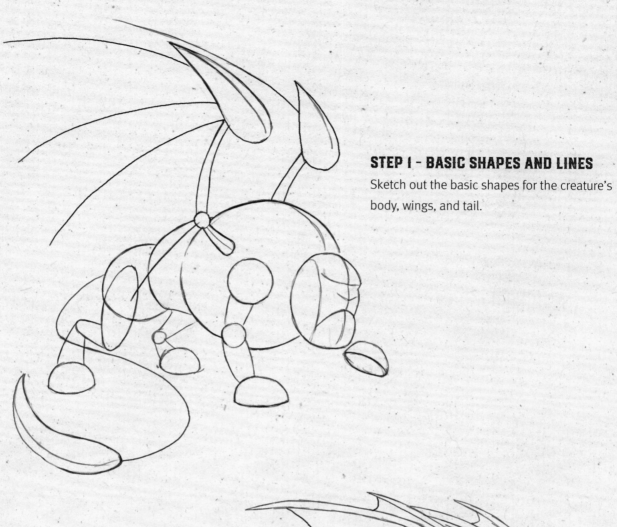

STEP 1 - BASIC SHAPES AND LINES

Sketch out the basic shapes for the creature's body, wings, and tail.

STEP 2 - BLOCKING IN SHAPES

Start fleshing out more of his wings, paws, and tail and start blocking in his face.

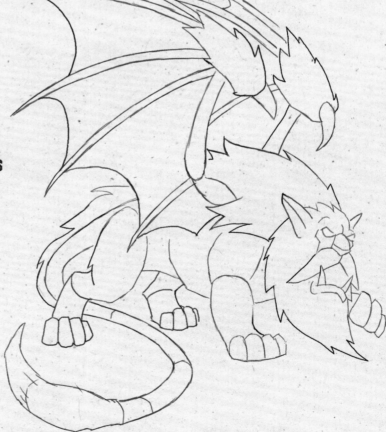

STEP 3 - ADD DETAILS

With this step we could call it done, but this is a complex monster, so I'd like to keep pushing more detail into his coarse hair and torn wings. We will keep adding details in the following steps.

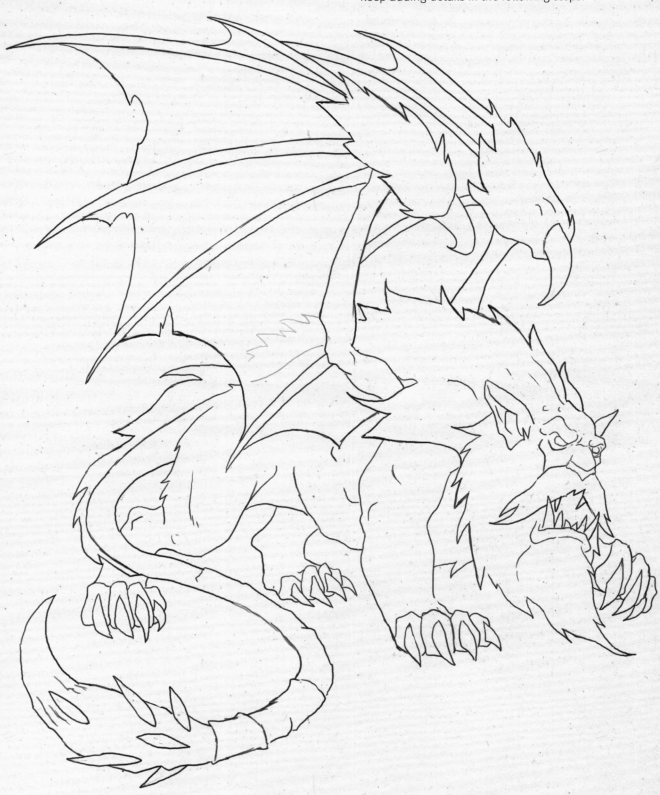

STEP 4 - CLEAN UP

Now let's rip up those wings even more and add some more spikes to his tail and back, and fill that mouth with more teeth.

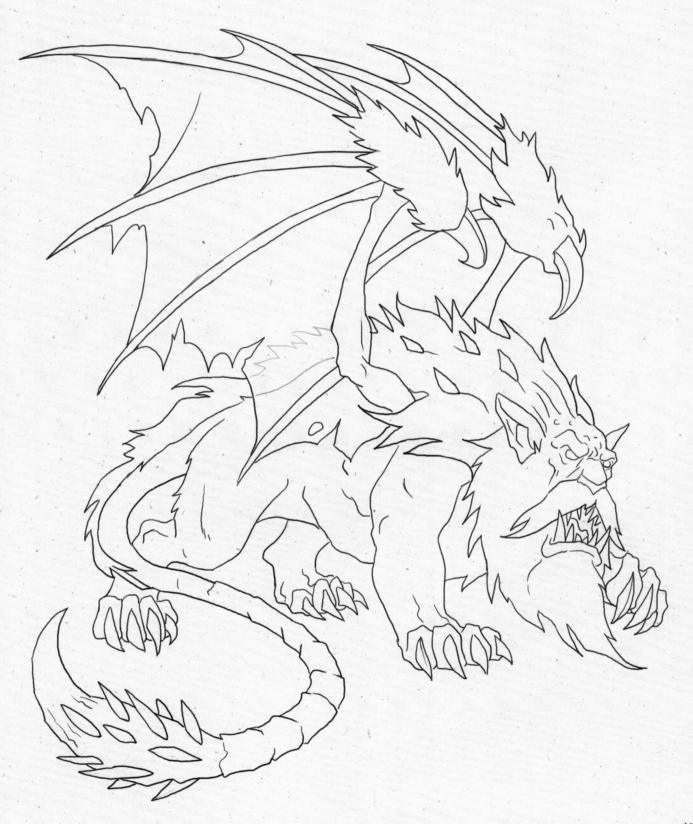

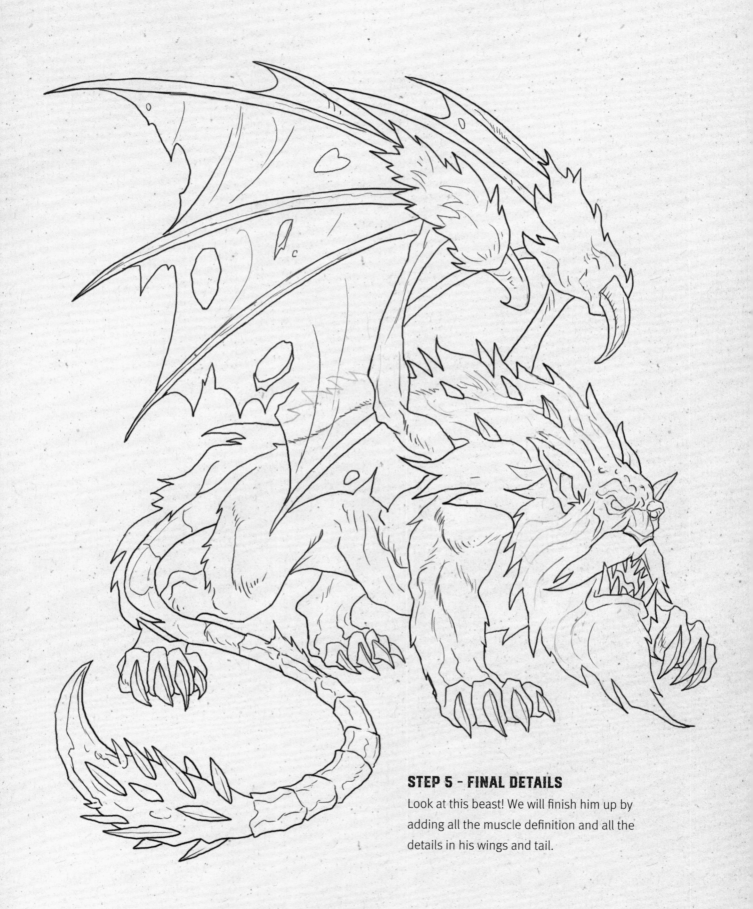

STEP 5 - FINAL DETAILS

Look at this beast! We will finish him up by adding all the muscle definition and all the details in his wings and tail.

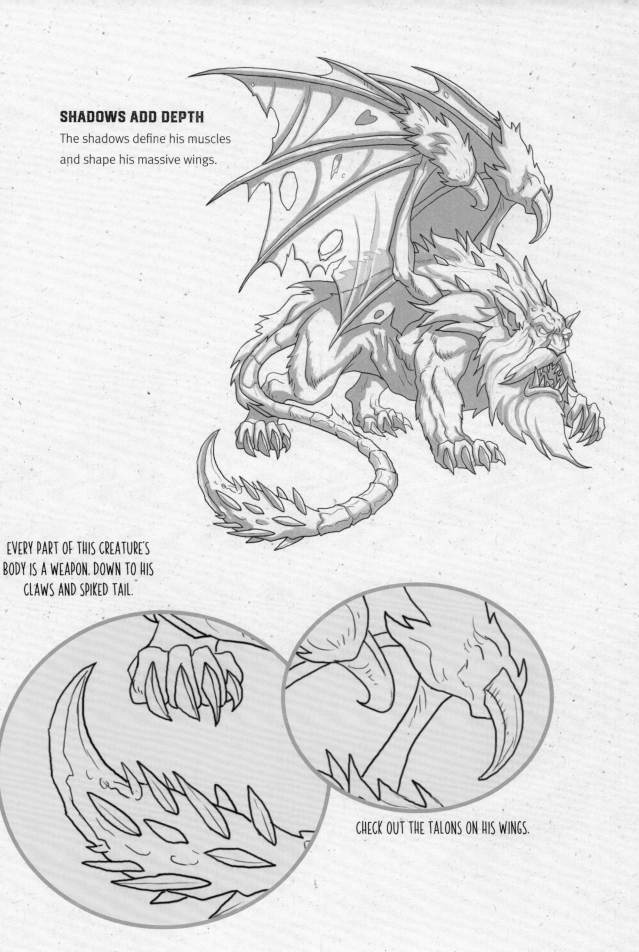

SHADOWS ADD DEPTH

The shadows define his muscles and shape his massive wings.

EVERY PART OF THIS CREATURE'S BODY IS A WEAPON. DOWN TO HIS CLAWS AND SPIKED TAIL.

CHECK OUT THE TALONS ON HIS WINGS.

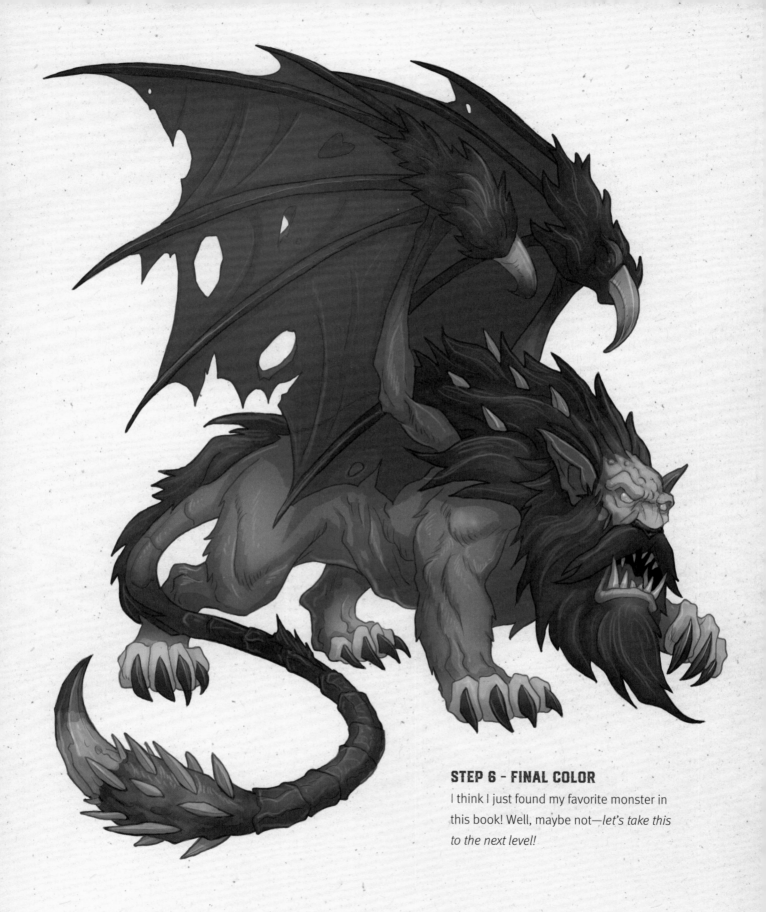

STEP 6 - FINAL COLOR

I think I just found my favorite monster in this book! Well, maybe not—*let's take this to the next level!*

THE TIGER STRIPES AND BRIGHT ORANGE COLORING REALLY CHANGES UP THE LOOK OF THE MANTICORE.

THIS MONSTER HAS A MORE REGAL LOOK NOW, AND MIGHT EVEN BE A RULER AMONG THESE MONSTERS.

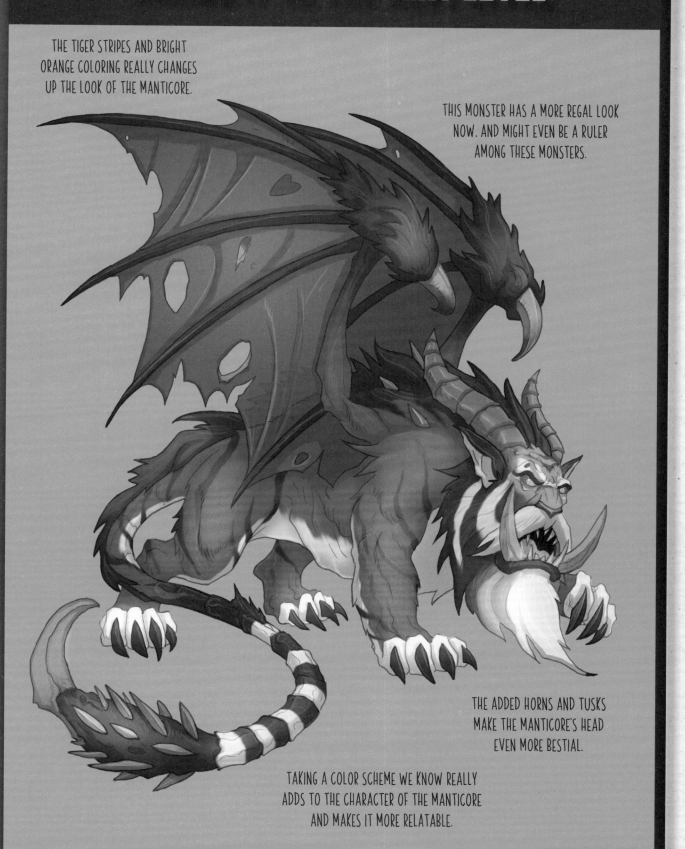

THE ADDED HORNS AND TUSKS MAKE THE MANTICORE'S HEAD EVEN MORE BESTIAL.

TAKING A COLOR SCHEME WE KNOW REALLY ADDS TO THE CHARACTER OF THE MANTICORE AND MAKES IT MORE RELATABLE.

THUNDERBIRD

ARTIST'S NOTES:

Tales have been told that the Thunderbird is so large that it was seen carrying a whale in its talons.

The stories of the Thunderbird have reached us from Canada and the Great Lakes, down through the Great Plains and into the American Southwest.

The Thunderbird is depicted as a gigantic eagle that soars through the sky, hurling lightning at its foes and creating tremendous thunderclaps when it flaps its wings.

THE THUNDERBIRD IS A SYMBOL OF STRENGTH AND POWER AND IS OFTEN DEPICTED IN NORTH AMERICAN INDIGENOUS PEOPLES' ARTWORK AND SONGS.

THOUGH STORIES AND LEGENDS VARY, ONE COMMON THEME AMONG THEM IS THAT THE THUNDERBIRD IS A GREAT PROTECTOR AGAINST THE ENEMIES OF OUR WORLD.

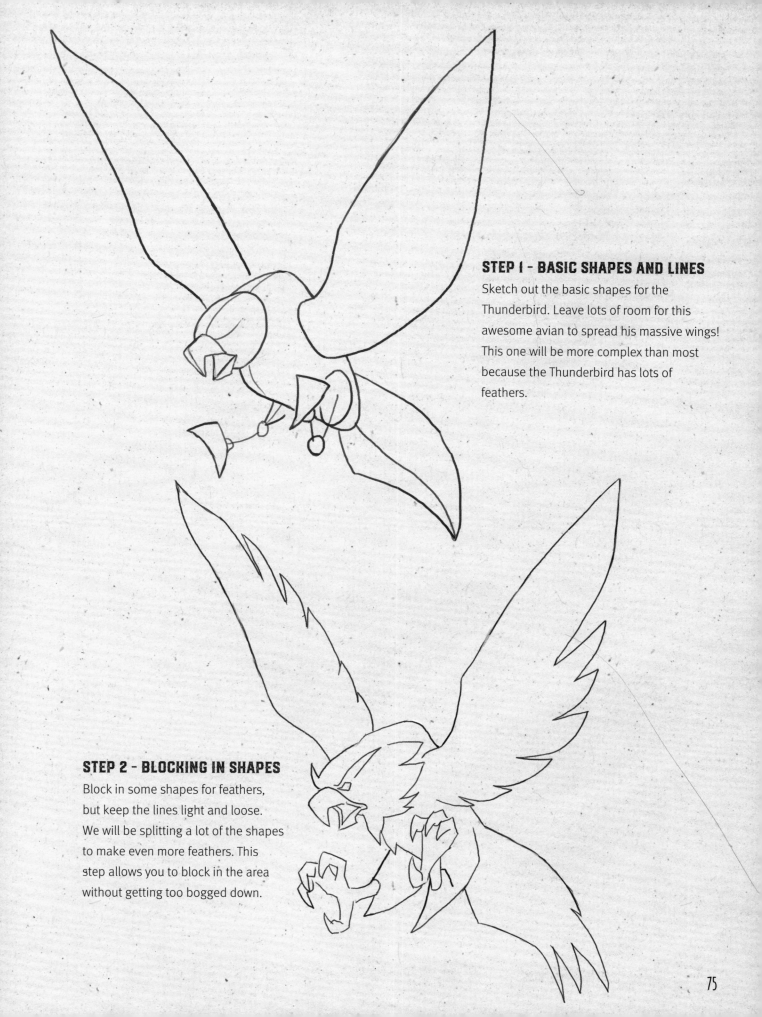

STEP 1 - BASIC SHAPES AND LINES

Sketch out the basic shapes for the Thunderbird. Leave lots of room for this awesome avian to spread his massive wings! This one will be more complex than most because the Thunderbird has lots of feathers.

STEP 2 - BLOCKING IN SHAPES

Block in some shapes for feathers, but keep the lines light and loose. We will be splitting a lot of the shapes to make even more feathers. This step allows you to block in the area without getting too bogged down.

STEP 3 - ADD DETAILS

With the areas blocked out, let's start
feathering up those wings.

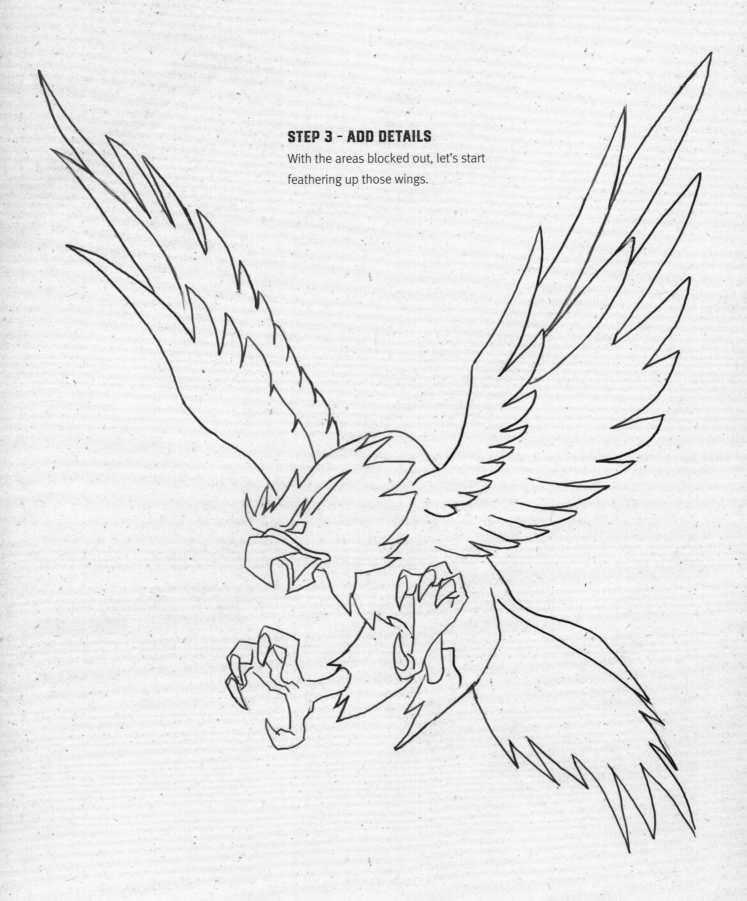

STEP 4 - CLEAN UP

Time to clean up all those feathery leftover lines and start defining everything we want to keep.

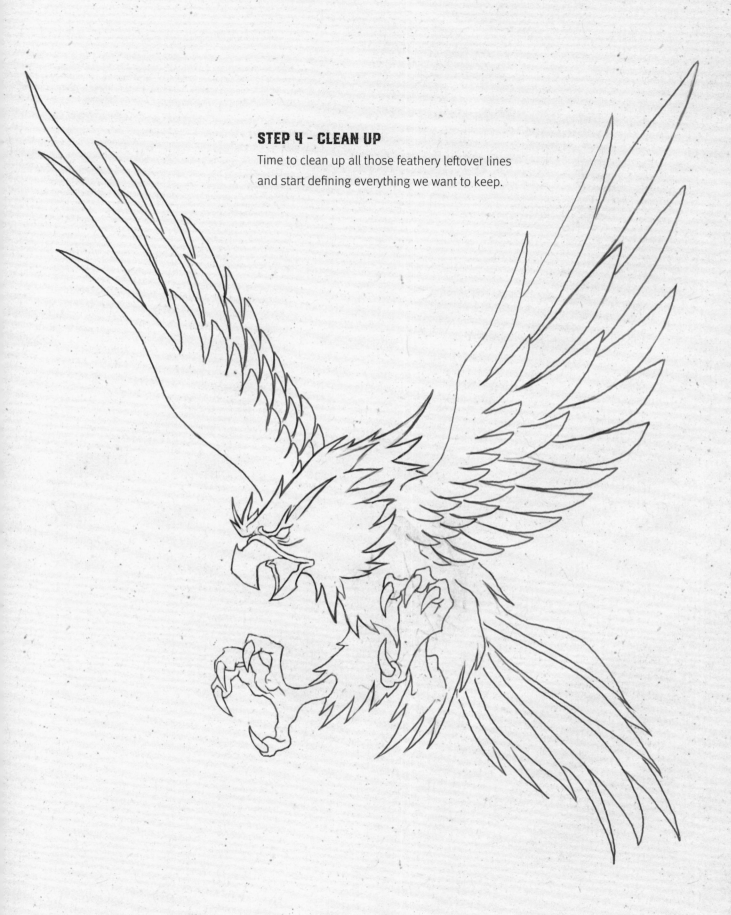

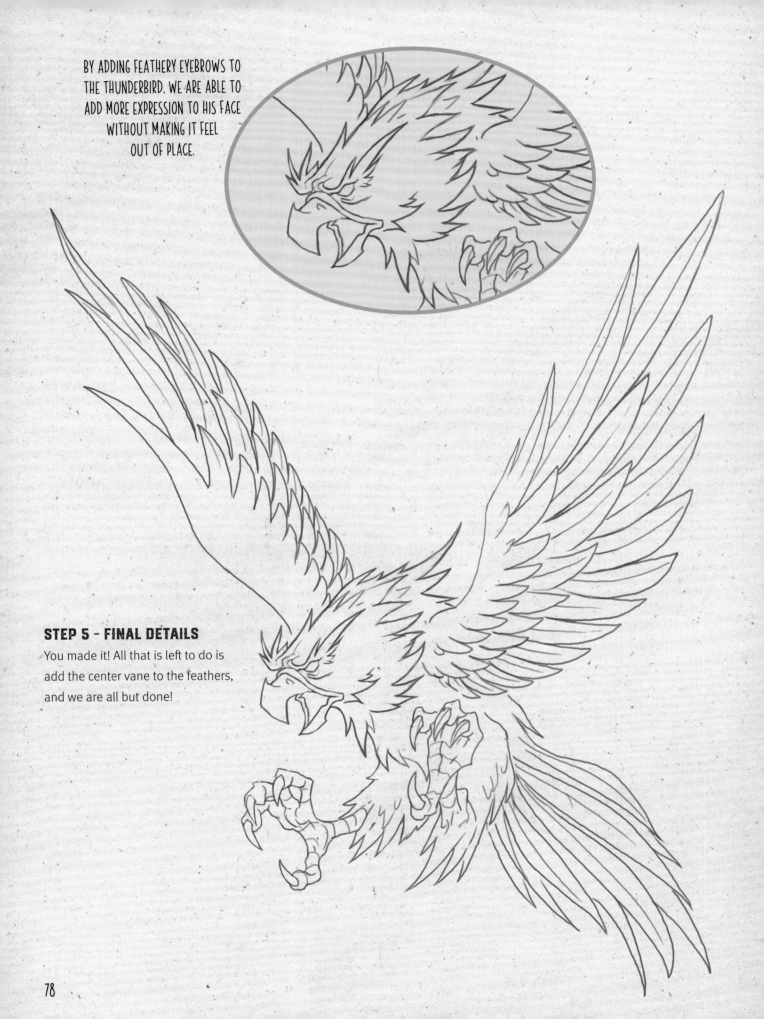

BY ADDING FEATHERY EYEBROWS TO THE THUNDERBIRD. WE ARE ABLE TO ADD MORE EXPRESSION TO HIS FACE WITHOUT MAKING IT FEEL OUT OF PLACE.

STEP 5 - FINAL DETAILS

You made it! All that is left to do is add the center vane to the feathers, and we are all but done!

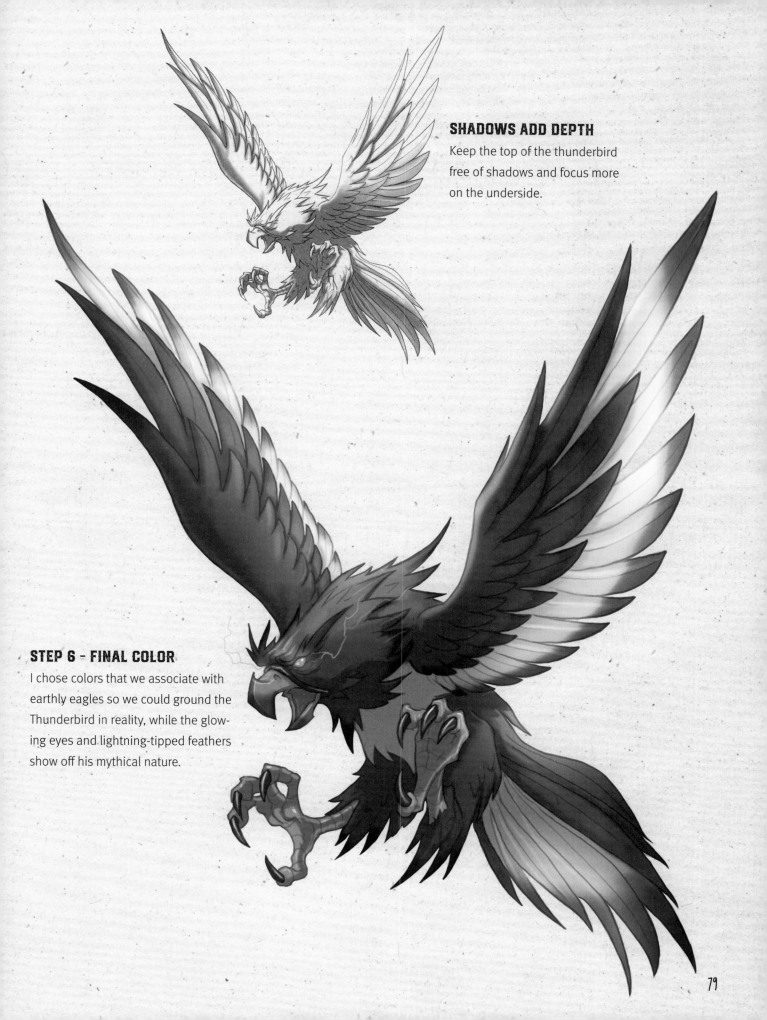

SHADOWS ADD DEPTH

Keep the top of the thunderbird free of shadows and focus more on the underside.

STEP 6 - FINAL COLOR

I chose colors that we associate with earthly eagles so we could ground the Thunderbird in reality, while the glowing eyes and lightning-tipped feathers show off his mythical nature.

QILIN

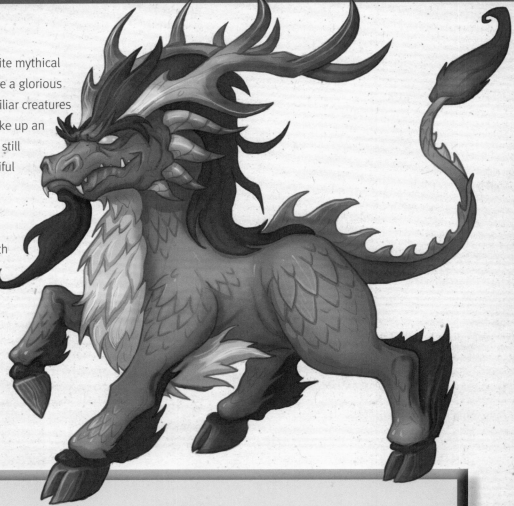

ARTIST'S NOTES:

Qilins are one of my favorite mythical creatures to draw. They are a glorious combination of many familiar creatures that, when combined, make up an entirely new creature that still seems familiar and beautiful to look at.

Qilins are widely known throughout mythology with countries like Japan, Korea, and Thailand all having stories about these beautiful creatures.

Though monstrous in appearance, Qilins are protectors against wickedness and evil, and are symbols of luck and longevity.

THIS CREATURE FROM CHINESE MYTHOLOGY POSSESSES THE HEAD OF A DRAGON. THE ANTLERS OF A DEER. AND THE HOOVES OF AN OX. ITS BODY IS COVERED IN SCALES LIKE THAT OF A FISH. AND ITS TAIL USUALLY RESEMBLES A LION.

THOUGH MANY QILINS ARE GOLDEN IN COLOR. MULTIHUED QILINS ARE ALSO COMMONLY SEEN THROUGHOUT FOLK TALES.

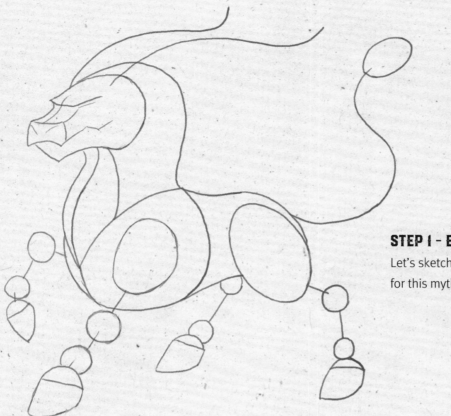

STEP 1 - BASIC SHAPES AND LINES

Let's sketch up the basic bones and form for this mythical creature!

STEP 2 - BLOCKING IN SHAPES

Now add the shapes for the antlers and his tail and hooves.

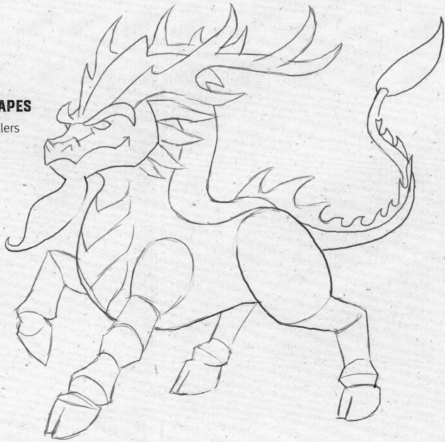

STEP 3 - ADD DETAILS

Keep adding details and refining your
shapes. Flesh out more features in his face
and add tufts of fur to his legs.

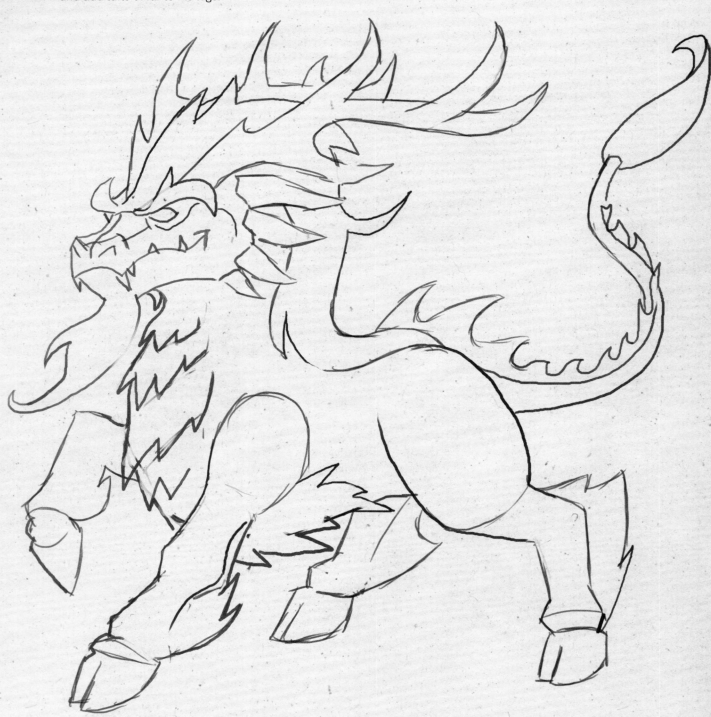

STEP 4 - CLEAN UP

Clean up your lines and keep adding more
details in his features.

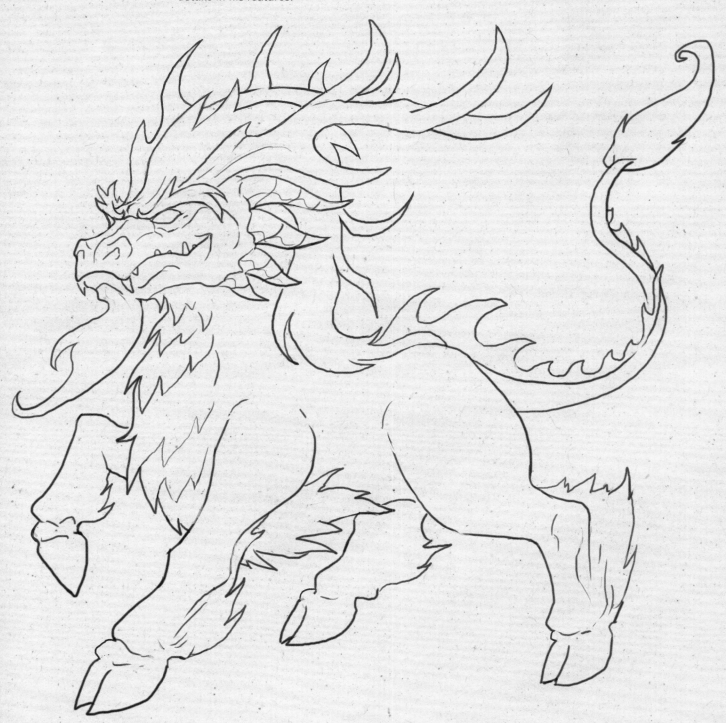

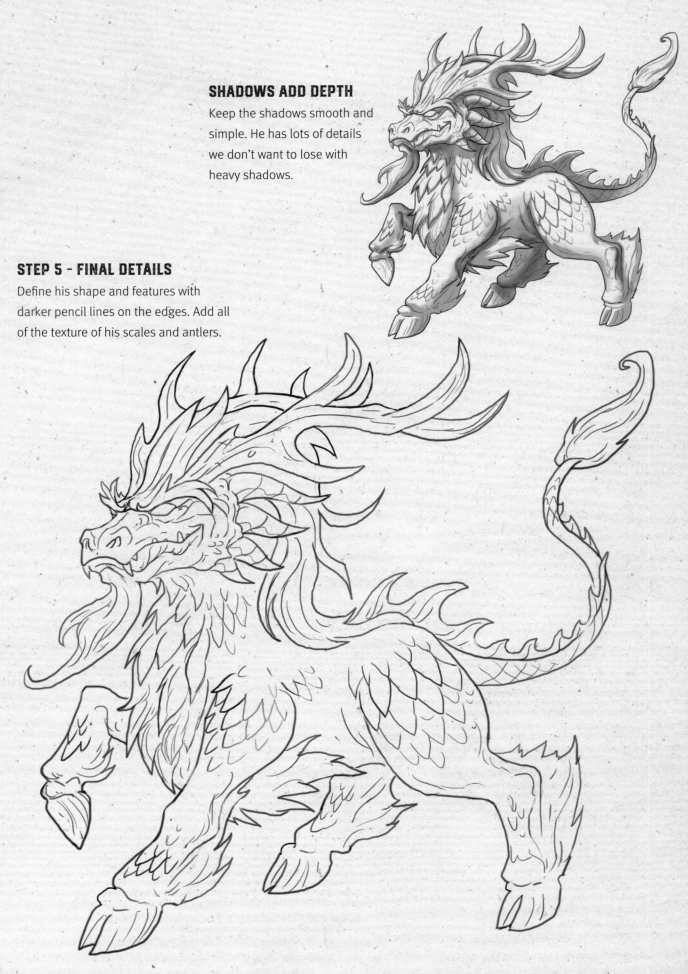

SHADOWS ADD DEPTH

Keep the shadows smooth and simple. He has lots of details we don't want to lose with heavy shadows.

STEP 5 - FINAL DETAILS

Define his shape and features with darker pencil lines on the edges. Add all of the texture of his scales and antlers.

HIS SCALY TEXTURE IS A MIX BETWEEN
FUR AND SCALES.

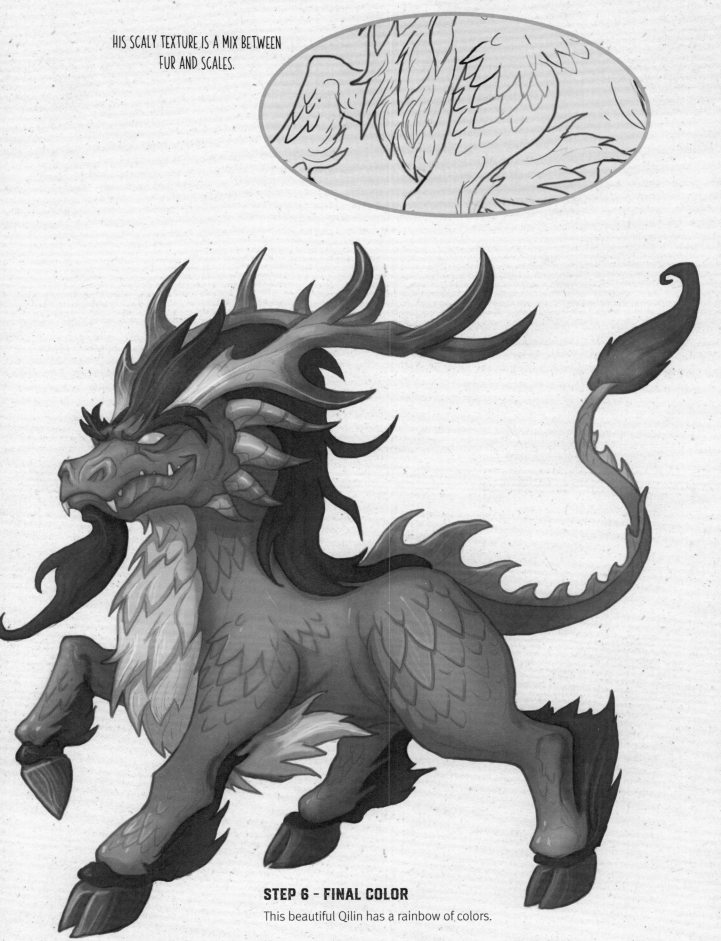

STEP 6 - FINAL COLOR
This beautiful Qilin has a rainbow of colors.

TROLL

Trolls are large, brutish creatures that dwell in isolated mountains, dark forests, and caverns, and are found in numerous stories in Scandinavian folklore.

Some Trolls have be found with not just one head but two or even three heads! I wonder which head gets to decide which way it is going to walk.

Be wary when crossing bridges, as Trolls have been known to dwell underneath them.

TROLLS POSSESS TREMENDOUS STRENGTH AND LIVE UNNATURALLY LONG LIVES: SO MUCH SO THAT THE REALLY ANCIENT TROLLS START TO TAKE ON THE CHARACTERISTICS OF THE ROCKS AND FORESTS THEY LIVE IN.

SOME TROLLS WILL GROW SO LARGE THAT IT ISN'T UNCOMMON TO FIND OUT THAT THE TREE YOU ARE RESTING UP AGAINST IS ACTUALLY THE LEG OF A TROLL!

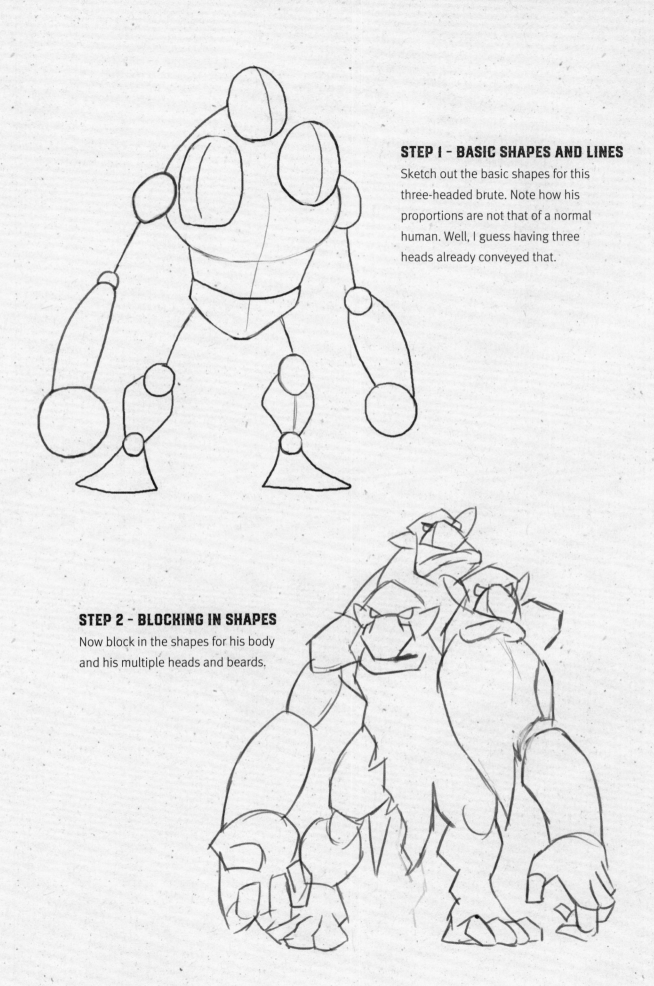

STEP 1 - BASIC SHAPES AND LINES

Sketch out the basic shapes for this three-headed brute. Note how his proportions are not that of a normal human. Well, I guess having three heads already conveyed that.

STEP 2 - BLOCKING IN SHAPES

Now block in the shapes for his body and his multiple heads and beards.

STEP 3 - ADD DETAILS

Notice how every feature is a bit jagged, and how he looks like he is carved from stone.

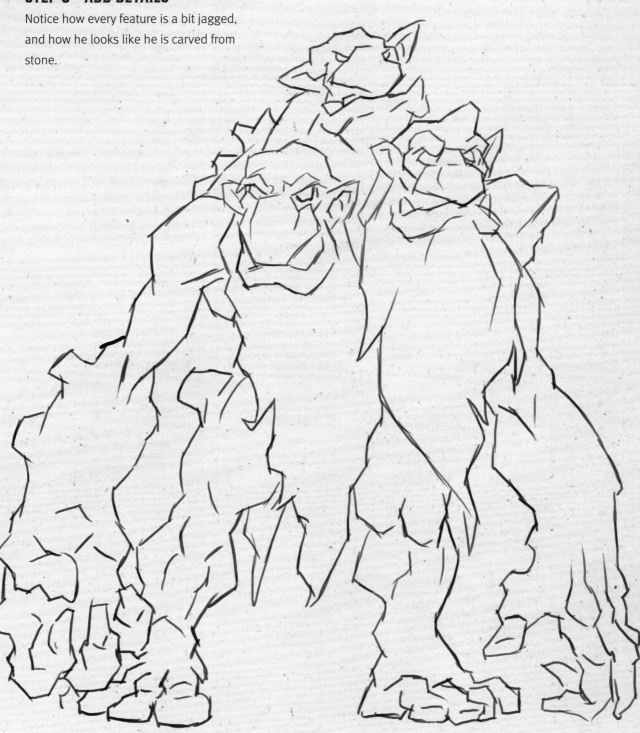

STEP 4 - CLEAN UP

Clean up your lines and add some more detail
to this three-headed creature. Now his limbs are
starting to resemble gnarled logs, and his fingers
and toes look like tree roots.

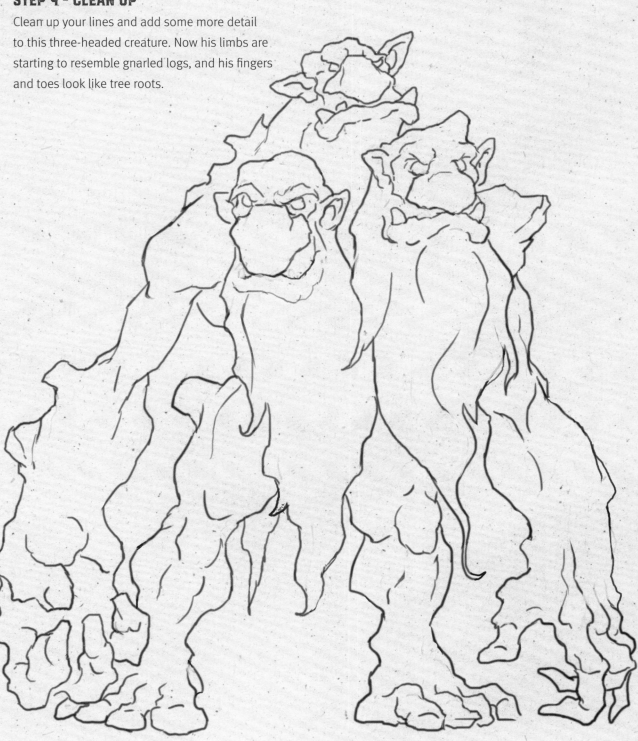

STEP 5 - FINAL DETAILS

Define his shape and features with darker pencil lines on the edges. Add texture to his multiple beards and knotty limbs.

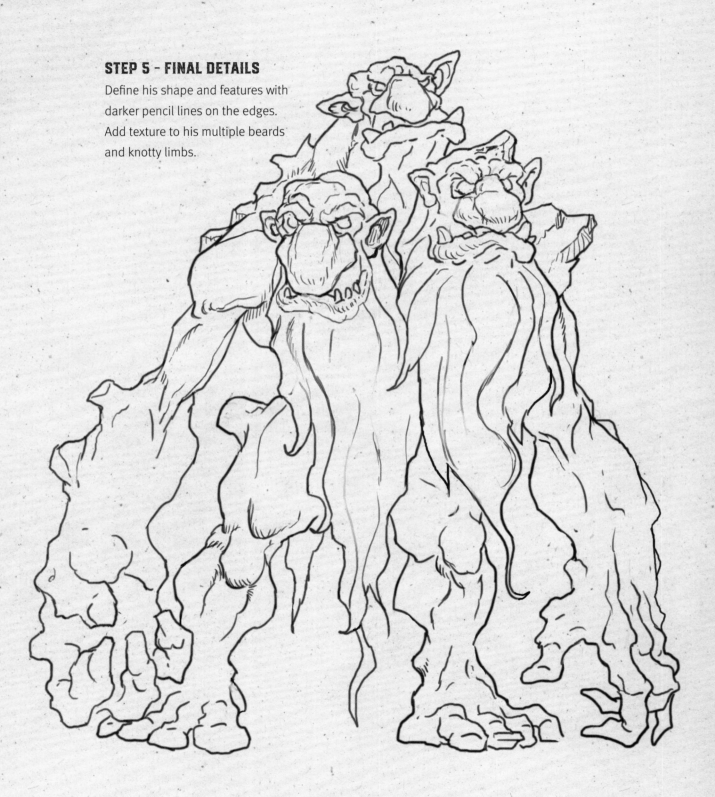

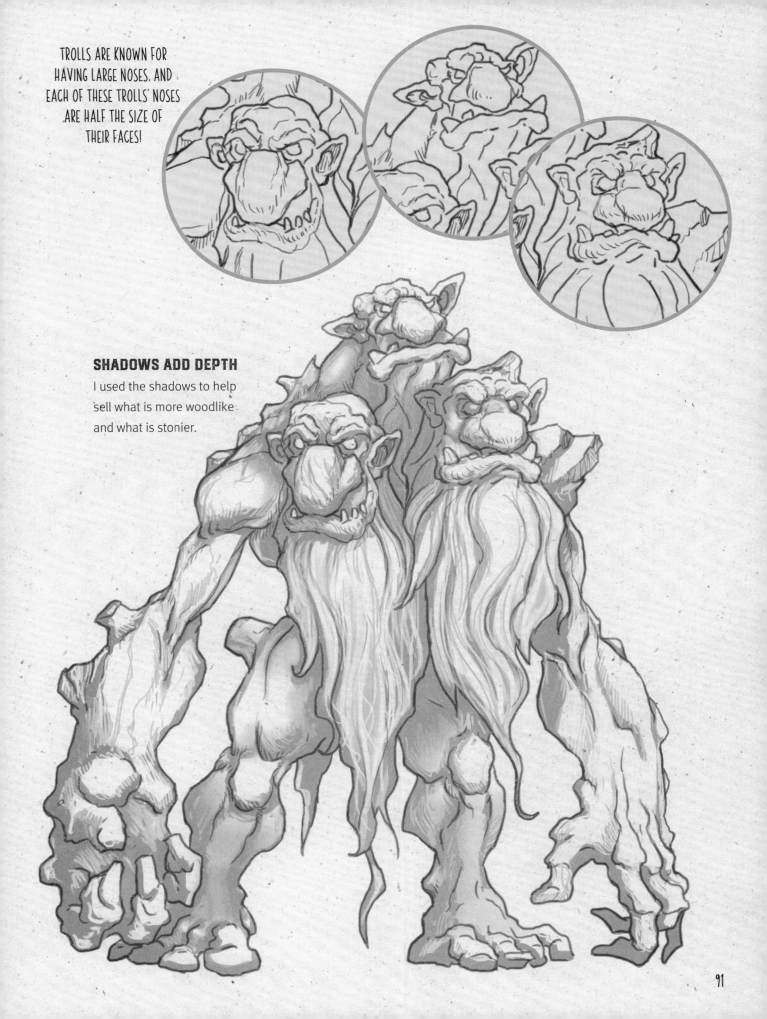

TROLLS ARE KNOWN FOR
HAVING LARGE NOSES, AND
EACH OF THESE TROLLS' NOSES
ARE HALF THE SIZE OF
THEIR FACES!

SHADOWS ADD DEPTH

I used the shadows to help
sell what is more woodlike
and what is stonier.

STEP 6 - FINAL COLOR

Since this mythical monster lives in natural surroundings, I went with a lot of greens, grays, and browns to show how much they are a part of the world they live in.

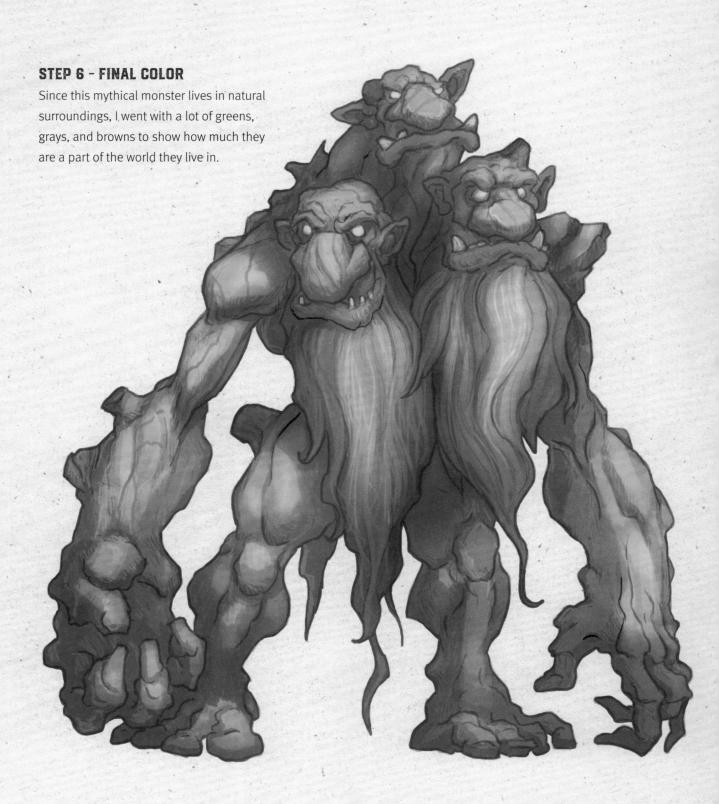

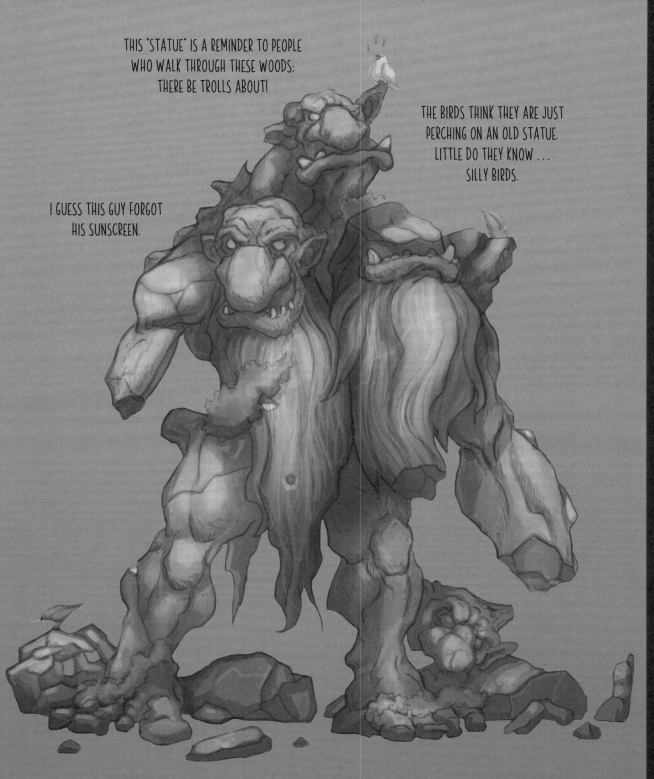

THIS "STATUE" IS A REMINDER TO PEOPLE WHO WALK THROUGH THESE WOODS: THERE BE TROLLS ABOUT!

THE BIRDS THINK THEY ARE JUST PERCHING ON AN OLD STATUE. LITTLE DO THEY KNOW . . . SILLY BIRDS.

I GUESS THIS GUY FORGOT HIS SUNSCREEN.

I WONDER IF THE TROLL IS STILL ALIVE AND JUST HIS SKIN TURNED TO STONE. OUCH.

93

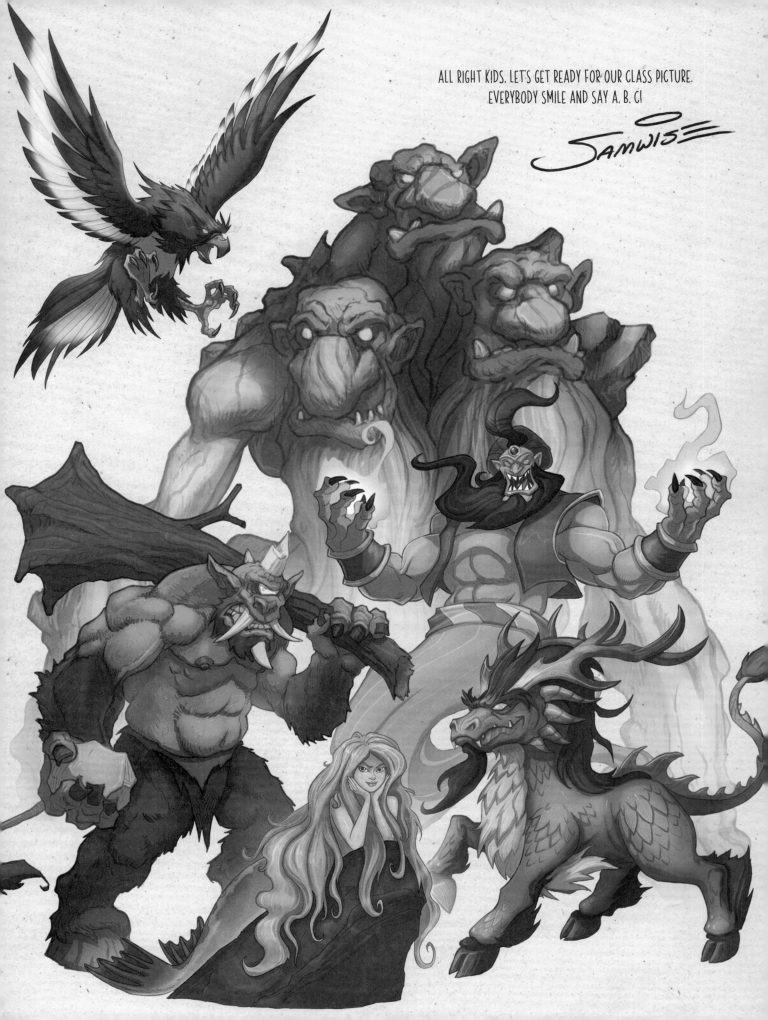

ALL RIGHT KIDS, LET'S GET READY FOR OUR CLASS PICTURE.
EVERYBODY SMILE AND SAY A. B. C!

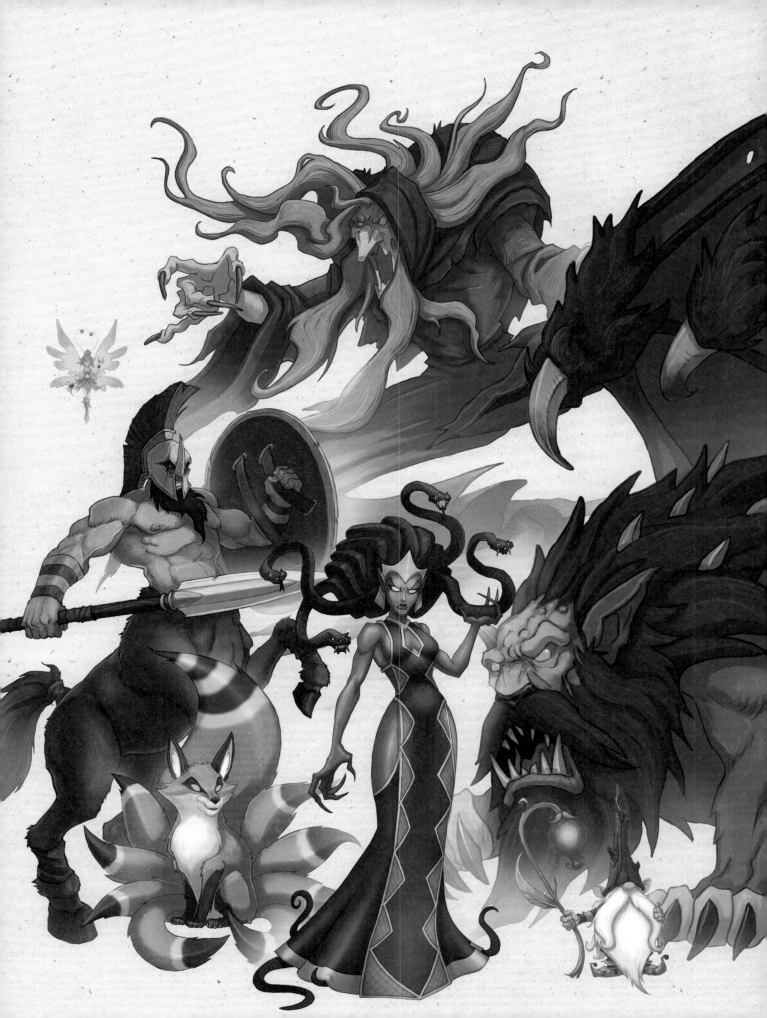

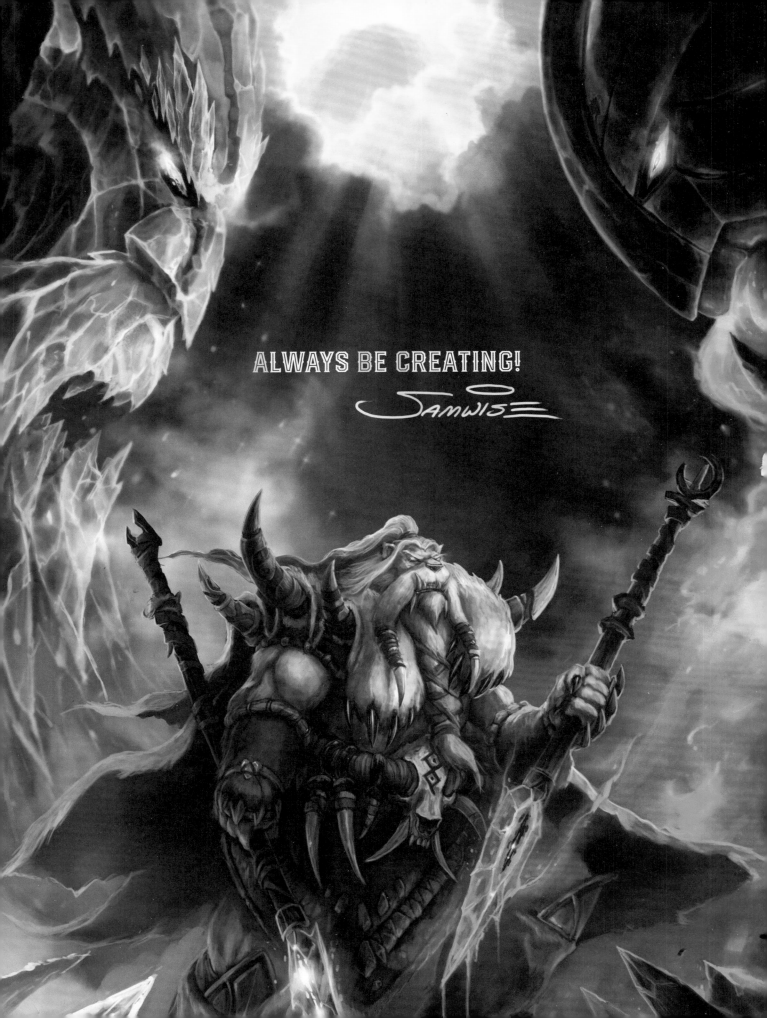

ALWAYS BE CREATING!

Samwise